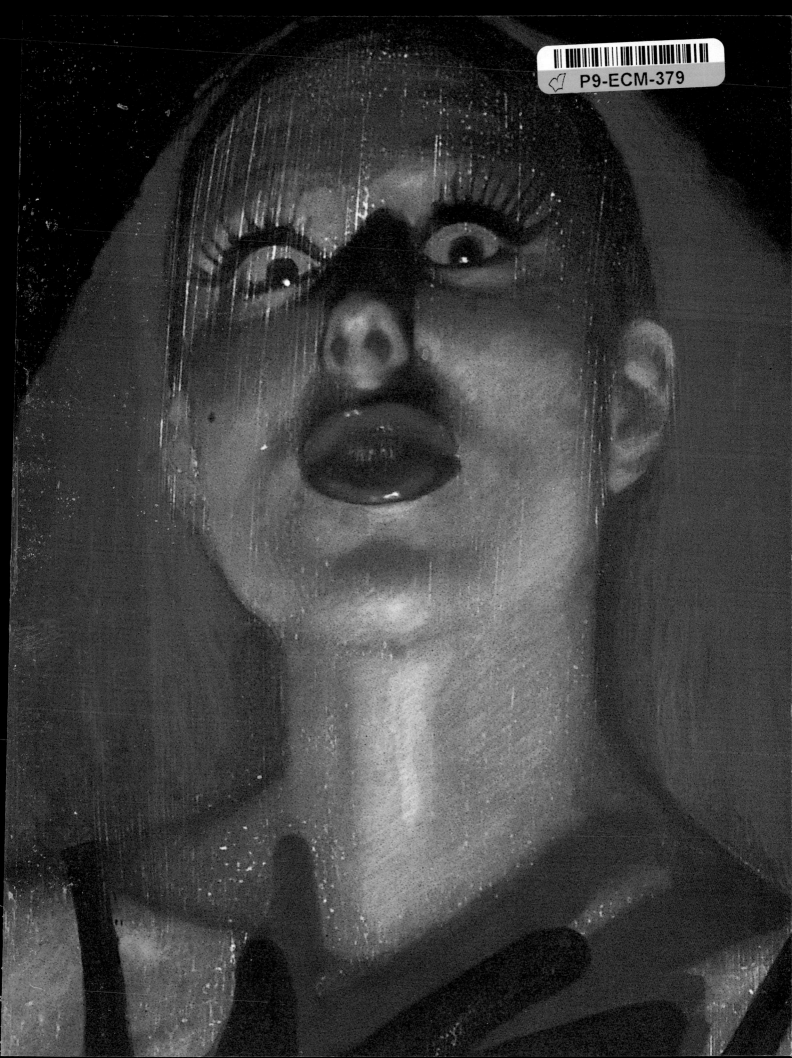

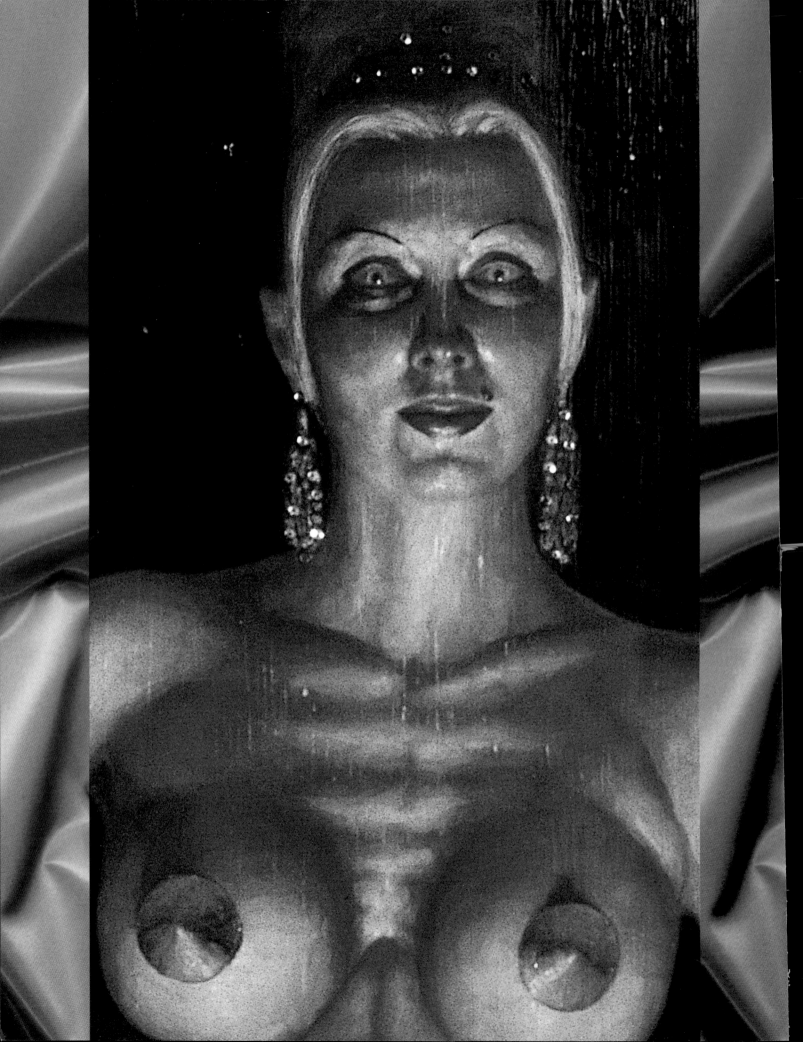

THE RED BOX

The
Phantasma-Allegorical
Portraits of

STACY LANDE

With a Foreword by
ROBERT WILLIAMS

Special Thanks To...

Ron Turner, Billy Shire, Frank Kozik,
Christine Karas, Robert Williams, Tom Bliss,
Carol Sheridan, Lisa Petrucci, Bob Roberts,
Emilie Harvey and all of the great artists
whose work has inspired this series:
Robert Williams, Brian Tucker,
Mario Calvano, Christine Karas,
Gary Matteson, Kari French
and Aaron Smith.

Related Websites

For more information on Tom Bliss:
www.tombliss.com

For more information on Stacy Lande:
www.veraandornon.com/stacylande

★

For Mom

ISBN: 1-86719-500-2 Published By Last Gasp, San Francisco. Book Design: Christine Karas.

Printed in Hong Kong.

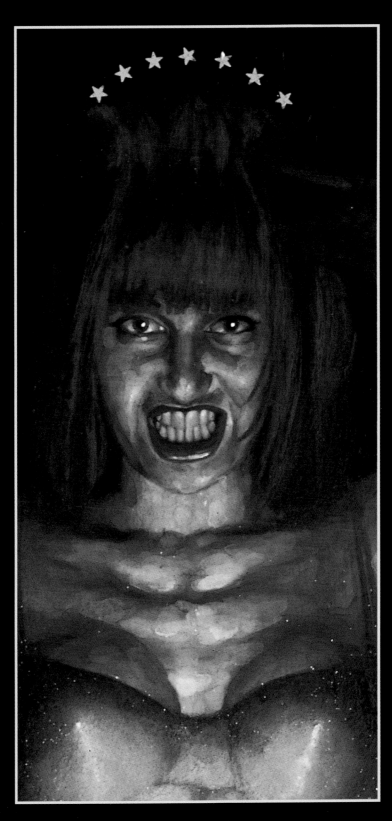

"The Idol Of Perversity"

CONTENTS

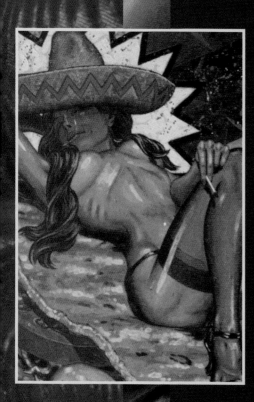

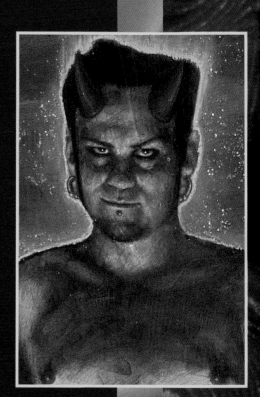

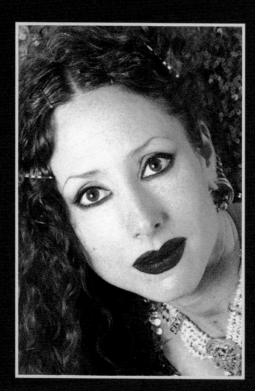

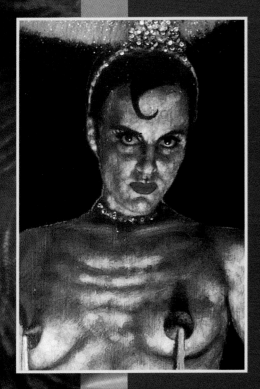

EARTH
Page 46

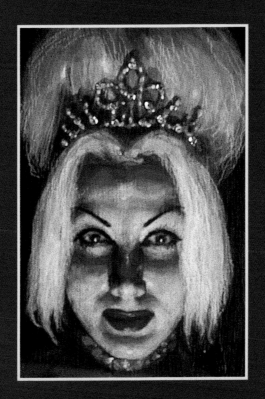

AIR
Page 64

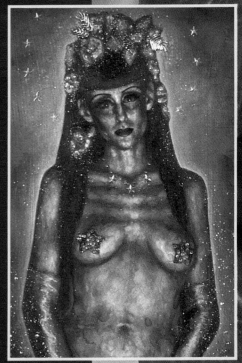

WATER
Page 78

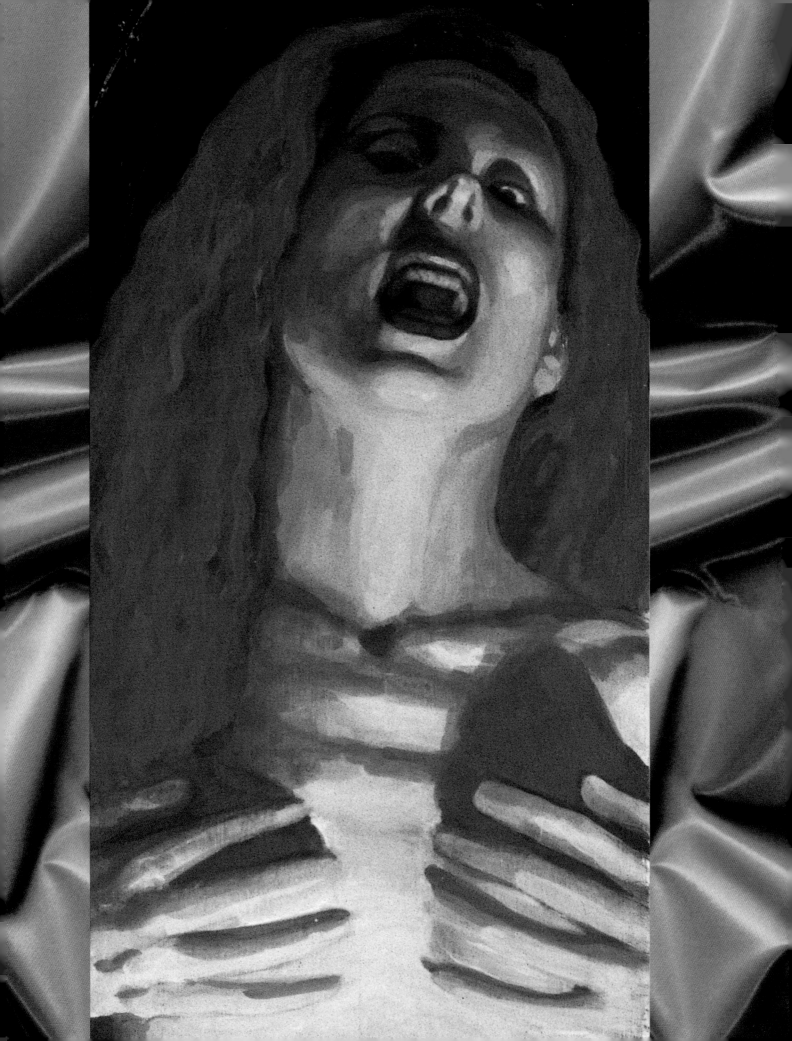

Ms. Stacy Lande, the Unabashed Portraitist
By Robert Williams

Like the tumultuous energy of post-World War I Weimar Germany with its decadent lust for life, the Silverlake area of Los Angeles has maintained its own form of zeitgeist for four or five decades. To many who are familiar with the denizens of this art community, one very attractive red-headed woman stands out. I am describing the person whose paintings you are about to explore, Stacy Lande.

And I mention the time of the turbulent Weimar Republic because the graphic gusto of the German Expressionists has been a great source of inspiration to Stacy for much of her career.

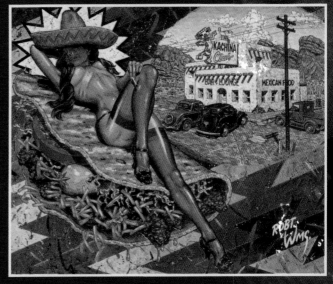

"Carne de Amore" by Robert Williams

Although formally trained as an artist, with a Bachelor of Arts degree from Cal State Northridge, Stacy's real rogue's scholar education came with her colorful pursuit of the cabaret lifestyle. An avid participant in the punk rock music world (a world incidentally that spawned L.A.'s underground art galleries), Stacy applied her pulchritudinous charms to popular stage dance opening for noted L.A. bands like L7 and Ethyl Meatplow, and for a short time attempted the performance skills of a professional stripper.

But her efforts as a serious artist is where her street-wise experience has payed off. It wasn't long (in the early nineties) before her ability as a painter and capable portrait artist was being realized. In fact, her portraits of some of the more familiar characters around Silverlake were gaining a certain notoriety.

Each of Stacy's paintings inherently contains an urgent energy, a result of her exclusive use of the vertical shaped wood panel to paint on. Painted in an almost Expressionist style with soft-edge brush work, every painting stares directly out into the eyes of the observer, and with a free use of hot reds, oranges, and blues, Stacy injects a melodramatic underlighting to give the impression that her subjects are reputed demi-gods on a metaphorical stage.

Her inclusion in important group shows and her successes in one-woman shows at this, the end of the twentieth century, is a good indication of what her future will bring. With her imposing figurative interpretations of various real people, all that's left is for her subjects to live up to their portraits.

For alternative art gallery-goers, there is no question about it, Stacy Lande is a significant chronicler of our impetuous times. With this said, let me offer you the enjoyment this book will bring you.

INTRODUCTION

By Tom Bliss

Photo: Annie Sperling

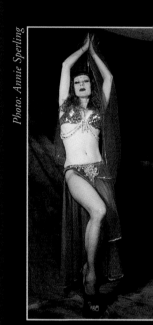

I first met Stacy Lande while catwalking onstage at a gaudy hair show, ironically enough. The typically redheaded glamour girl appeared from the wings like some ungodly Hieronymous Bosch vision, a semi-naked mud creature flinging her filth onto a startled and appalled crowd of chi-chi scenester wannabes. It was a fairly hilarious revolt against poser expectations. The next time I spied the dirt goddess, we were both doling out espresso at the infamous Onyx Cafe in Silverlake, one of the last vanguards of 60's bohemian coffee counter culture. She wore combat boots and a flower dress, waved her arms like some manic Minnie Mouse and called everyone "Hon". I was shocked at her infectious charisma and reckless creativity, doubtful that anyone could sustain such an outrageous persona, but she was easy to beat at Gin Rummy and so we became friends.

Over the years her outrageous persona has thankfully remained pure, with the welcome addition of towering platform shoes and sexy miniskirts, and trademark exclamations of "whoo-hoo" accompanied by spontaneous applause at the hint of any excitement, a leggy dominatrix Lucille Ball in cheesecake drag. The delicious cartoonery has revealed remarkable artistic depth and intellectual acumen aside all the hysteria and glee, and it's this very juxtaposition of opposite natures — the fleeting party girl and the sober genius — that create such an intriguing, great myth to the shtick of her being.

Stacy Lande grew up in Granada Hills, a precocious valley girl who staged elaborate talent shows on the front porch and won prizes at art fairs in the parking lot of the local mini-mall by the time she was eight. Her adoring and patient suburban family unit exhibited zero artistic inspiration — her father owned a linen supply company, her mother was a housewife, they kept a semi-kosher house and

Photo: Maria Boyd from the collection of Stacy Lande

The view from the Silverlake Hills

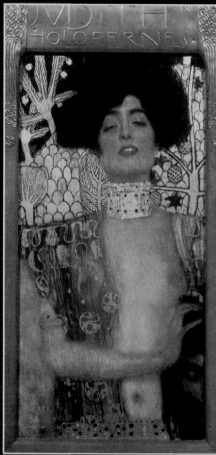

Stacy's primary influence:
"Judith I" by Gustav Klimt

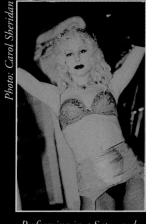

Photo: Carol Sheridan

Performing in a Satyr and Nymph piece at The Big Bang

Photo: Carol Sheridan

Every girl should have a glamour shot on hand

perhaps a claustropho-bically sane existence. They would never quite understand Stacy's early and endless renderings of ultra-vixen bombshell showgirls with false eyelashes, slinky fishnets and heaping cleavage — the kindergarten pornographer doubtlessly inspired by Bob Mackie and James Bond babes. Her first portrait at age seven showed a startling eye for realism. Already she fixed her subject, a hapless aunt, with candid confrontational glares towards the viewer like some pre-pubescent Arbus, while the devoted commitment of every line and crevice greatly disturbed the poor woman to no end. Stacy's inexplicable aestheticism found its sole connection in a fragmented account of her adoption, which was this: her birth mother loved to dance and her birth father was an engineer. Otherwise she might have been an alien for all her inclinations. A recurring fantasy marked Stacy's childhood monotony, daydreams of being a tough superheroine and kicking everyone's ass, only to be captured and tied up at the boys' whim. In reality, she was admittedly an awkward, chubby, red-haired, buck-toothed with braces, goofy adolescent, an easy pre-

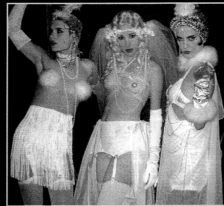

cursor to Dawn Wiener in "Welcome To The Dollhouse" by fellow film freak Todd Solondz with whom she actually spent the better part of a kibbutz and parental sojourn in her twenties. Twice cast as the over-eating best friend on different soap operas, Stacy emerged from youth with only that powerful need to break free.

Punk rock in Los Angeles in the late 70's provided the catalyst. The Screamers, Weirdos, Dead Boys and Iggy Pop fueled her rebellious fire; and delirious, expressionistic films like "Nosferatu", "The Cabinet Of Dr. Caligari", "Cabaret" and "Eraserhead" ignited her flame. And as if to temper these burning nights of the were-diva, Stacy attended school by day at Cal State Northridge where she found a mentor in Saul Bernstein. With his popular bravado and boundless passion, Bernstein became a romanticized father figure shepherding her progress, a swashbuckling Gomez Addams type who instilled the mysteries of the old masters, the use of color theory to build up skin layers and recipes for glaze mediums, Rubens and Rembrandt as taught by some galloping gourmet.

Left: Stacy (center, in blonde wig) posing with other go-go dancers at Cunt Club's Erte Winter Wonderland Night

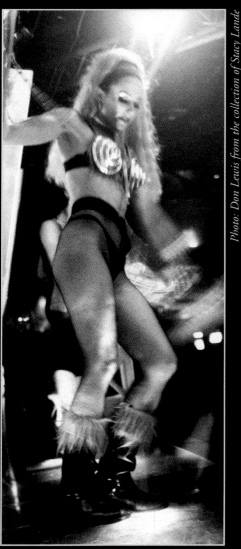

Photo: Don Lewis from the collection of Stacy Lande

Go-go dancing at Club 2001

Photo: Carol Sheridan

Stacy (center, in beehive) with go-go dancing pals at Cunt Club's John Willie Night

Go-go dancing with Tim
at Sin-a-Matic

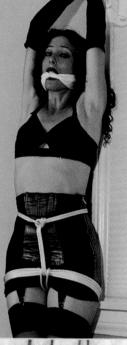

Photo: C. Jerry Kutner

This was the cover for
"Simone Devon's Bondage
World" magazine

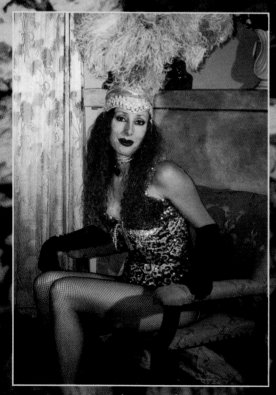

A typical evening at home

Photo: Emilie Harvey

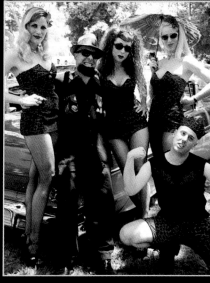
Stacy and her fellow trophy presenters Halle, Annie and Tom Bliss are joined by artist The Pizz at the annual "Blessing Of The Cars"

By the time she'd earned a B.A. in 1984, Stacy had achieved enough academia to express her peculiarly driven bent — providing lasting structural form to the cherished chaos around her by memorializing the creatures of the nightlife. Stacy herself thrives on social expression; her impact on clubland has proved a mutually beneficial dalliance for many years. Besides brush-stroking the egos of the underground, Stacy has shaken up the podium at Sin-A-Matic, Spit! and the Cunt Club, graced the stage alongside Rube Ruben, L7, and Theatre

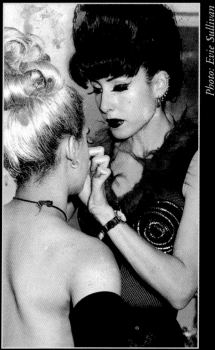
Photo: Evie Sullivan

Helping another go-go dancer with her lashes

Carnivale, and posed for bondage fashion and LFP's Leg World spreads. With her burlesque abandon and gogo spirit, she's a sexy shot in the arm of enthusiasm for many a jaded function junkie; her presence heightens any happening. I've wisely cast her in copious performance art casualties, knowing only too well that in those, ahem, rare moments where the rehearsals don't exactly occur, her effusive impromptu presence can salvage scenes where mere pre-written words could never comply.

The devils, Greek gods, kings and martyrs of her archetypal paintings can be found haunting the shadows of the Silverlake scene, a thriving and incestuous artist community circa turn-of-the-century Los Angeles. Haunted Garage front man Dukey Flyswatter's spunky naked Pan portrait adds a certain carnality to Clive Barker's personal collection, while Bauhaus' David J. masquerades as a shady Hades, 'Pussy Printcess'

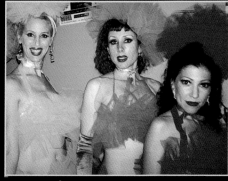
Annie Sperling, Stacy and Crissy Guerrero in costume for Marlene Dietrich's "Laziest Gal In Town" burlesque number

Kari French bares her inner Demon Girl, and an Idol Of Perversity becomes Lydia Lunch whose own experimental "Black Box" anthem inspired generations of punk passion. Stacy shoots her model wads while sprawled across apartment floors, underlighting the costumed subjects from low angles to larger-than-life effect. Wet acrylics, sequins and glitter are generously applied to abandoned cupboard doors, and her dispossessed ethereal images emerge from the process like the residue of a tea reading. Her technique is her mindset — an

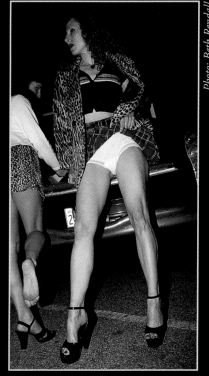
Photo: Beth Rendall

Posing for an LFP "Leg World" photo layout

emotional, altruistic, wholly involved supernatural heroism that seeks to elevate the mundane to the immortal, to alchemically transmute the lead of lost souls into gold.

The end product is nothing less than a stunning, heartfelt summons of so many modern vainglorious zombies trapped in theatrical artifice and obsessed reverie. The rage and passions that she illuminates in her subjects overshadow one's ego like a malignant twin, one that will feed off your self-perceptions so that it may live, a golem on the wall that enchants and enraptures and will one day bury you. These phantasma-allegorical paintings spill out of their Gustav Klimt-ian doorway coffin frames like hideously beautiful, sacred beasts resurrected from the glittery blaze of their glory days. And an enlightened evil is unearthed from another Pandora's Box of delights onto an unsuspecting world, a world tempted by the promise always of brighter things to come, a world seeking to reclaim forgotten myths that have been extraordinarily forged anew forever here by the precious, procreative and impenetrable "Red Box" of Stacy Lande.

Model Ghia beside her painted likeness
at Stacy's La Luz de Jesus Gallery opening

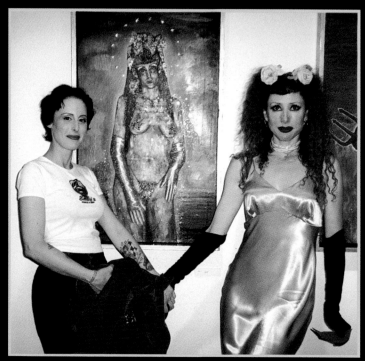

Lovely model Mara Levarre is "La Mer" at La Luz de Jesus opening

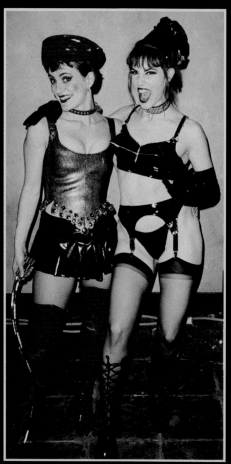

Stacy's favorite models Ghia Avesani and
Kari French model in a fetish fashion show

"*S*tacy Lande is
the painted voice
of a pagan dialect
of sensuality."

Chris Birkbeck

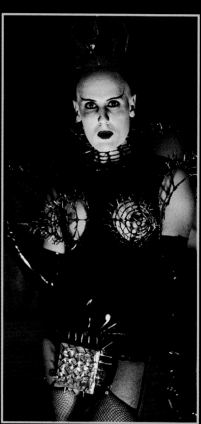

Writer and artist Tom Bliss, dressed
to kill for a performance art piece

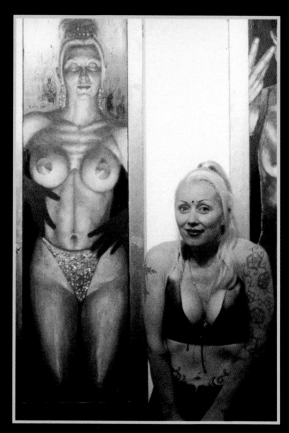

L.A. clothing designer Sweet P
is depicted in Stacy's painting "Olympia"

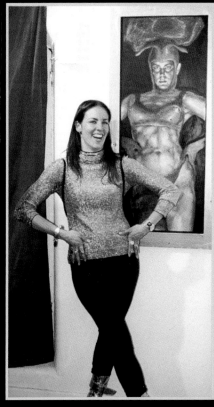

Kari French shows everyone that she was
the inspiration for "Ophelia II"

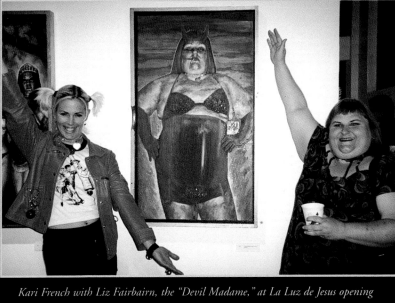

Kari French with Liz Fairbairn, the "Devil Madame," at La Luz de Jesus opening

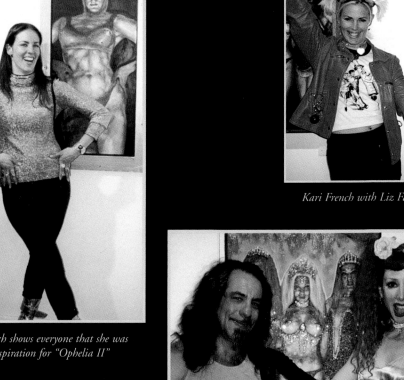

FRIEND! The artist with La Luz de Jesus Gallery
owner Billy Shire

BANNED! Two of Stacy's paintings were
ousted from an erotic art exhibit in
Los Angeles due to alleged Satanic
overtones. Stacy (left), Brendan
Mullen and model Robyn Westcott
with the offending pieces
"Li'l Lucifer" and "Anima Bendita."

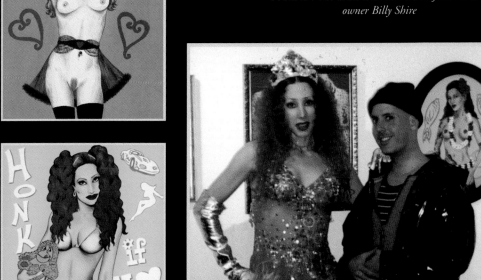

A favorite model of pin-up artist Christine Karas, Stacy joins pal
Tom Bliss for an enthusiastic appearance at Christine's
La Luz de Jesus pin-up calendar signing. Christine depicts
Stacy in "Valentine Vixen" (upper left) and
"Honk If You Love Jesus" (lower left).

"*S*tacy's characters
become the embodiment
of the Archetypal..."

Lisa Petrucci

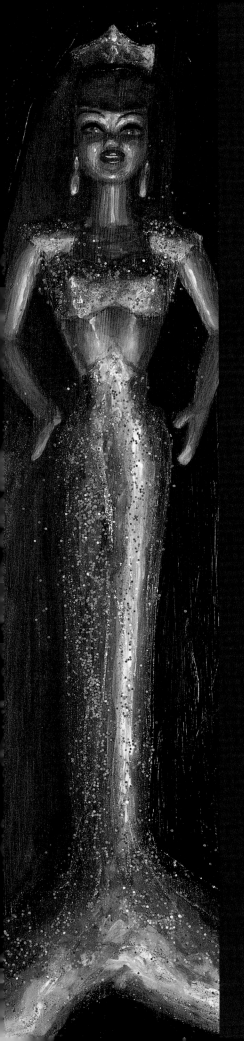

 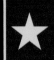
Now here's a lady who dares to make art that imitates life. Stacy Lande, visual artist and exotic dancer all rolled into one lovely and talented package. Since the early nineties, Stacy has been dancing at various alternative nightclubs in Los Angeles and documenting this outrageous underground community in exquisite portrait paintings of the many colorful performers, dancers, artists and friends she's come to know over the years. Done in an old masterly style and painted on old, discarded wooden cabinets, Stacy's paintings not only capture the individual characteristics of her models, but an altogether unique, otherworldly creature emerges from the rich layers of acrylic and glazes she uses. Glowing chiaroscuro and stark underlighting create an ambivalent aura that radiates from her unearthly subjects. Exaggerated and theatrical, confrontational and unflinching, hypnotic and aggressive — Stacy's work reads like a photo album from Hell where voracious sexual demons mysteriously appear out of a velvety darkness.

In this infernal territory, Stacy's characters become the embodiment of the archetypal, — those mythical personas populating the male and female subconscious. Salome, Judith, Lucretia, Delilah, Jezebel, Circe, Leda, the Siren, the Maenad, the Incubus, the Succubus, the Sphinx, the Chimera, the Bacchante, the Temptress, the Vamp(ire), the Whore and the male equivalent of the Incubus and Pan exist for us now as much as they did centuries ago, thanks to Ms. Lande.

The many portraits Stacy's done take their inspiration from a wide array of art historical sources, especially the book "Idols of Perversity," a critical examination of the fin-de-siecle culture of the 19th century

by Bram Dijkstra. Interestingly, Stacy has produced her work at the end of the 20th century. The fin-de-siecle was marked by "the Victorian obsession with voluptuous, allegorical women who suck the lifeblood out of men." The notion and fear of the dangerous and diabolical woman as the destroyer of man was a prevalent theme in art and literature, and is reflected in works by the post-Impressionists Edgar Degas and Toulouse Lautrec, but more specifically those of the Symbolists: Gustav Klimt, Gustave Moreau, Edward Burne-Jones, Fernand Khnopff, and Edvard Munch.

Stacy has also drawn upon the bohemian decadence of German expressionists like Max Beckmann and the anti-bourgeois sentiments of the New Objectivity movement of the twenties, exemplified in the works of Otto Dix and George Grosz. Like Stacy, these artists left behind a visual record of the unconventional people and places, the nightclubs and cabarets, and the dancers and entertainers who populated the avant-garde of their time.

On a more basic level, Stacy is painting alluring pin-ups and has been doing so since she was a child. Representations of strong, self-possessed, independent, sexually-empowered women (and men) who revel in their own strength and beauty. Post-feminist and sex-positive, they go far beyond idealized eye-candy. Instead of "the-girl-next-door" of traditional pin-up masters like George Petty and Gil Elvgren, the bad girl and femme fatale are held up as the ideal. The badge of today's feminist is a push-up bra, lipstick and stiletto heels — which she proudly wears with confidence and a touch of arrogance.

Art history aside, Stacy is in a league of her own, painting a sensual world that straddles flesh and fantasy, myth and modernism.

Lisa Petrucci
Seattle, Washington

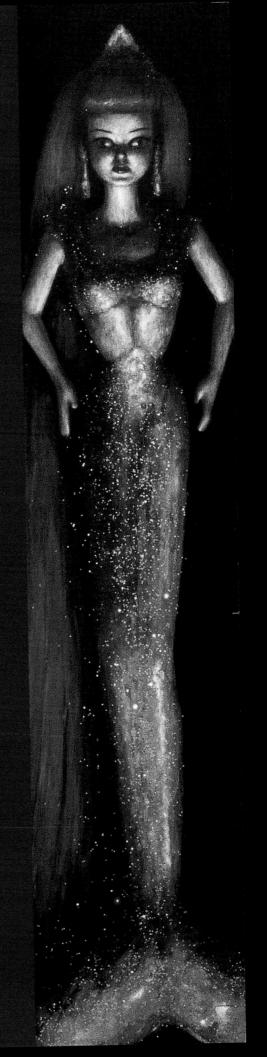

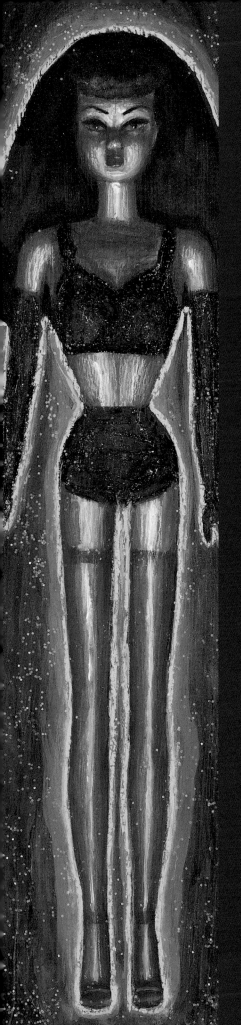

Bridging a one-hundred year gap to the rotting splendor of Western Civilization's last Golden Age, the phantasmagorically erotic work of Stacy Lande provides a fitting riposte to a century of bland, sterile sexless 'art'. Working in the long ignored tradition of true, human representational Fine Art, these compelling portraits offer an intimate glimpse of another secret universe, a dark Bohemia residing in the core of this century's premier Gilded Lily...Los Angeles.

Brooding images, lush dark colors, a complicated technique of endless layers combined with fetishized costumes of Lande's own creation imbue these portraits with a tactile presence that reveals the timeless forces inherent within the subjects. Lande's work transforms 'normal' people into symbols...icons of power, of sexuality, of death.

An almost rigidly formal use of discarded substrates — doors, window shutters, furniture pieces — adds yet another layer of Gothic splendor to the paintings, mirroring the artificial re-cycled nature of all art against Los Angeles' urban decay...the frames seem a fitting substitute for any background detail which would serve only to impede the electric connection between the viewer and the pieces.

Above all else, Lande's work embodies to me what is truly powerful in art...images that are intensely personal, organic and self-contained, yet able to impart endless worlds of fantasy... whatever yours may be.

Frank Kozik
San Francisco, California

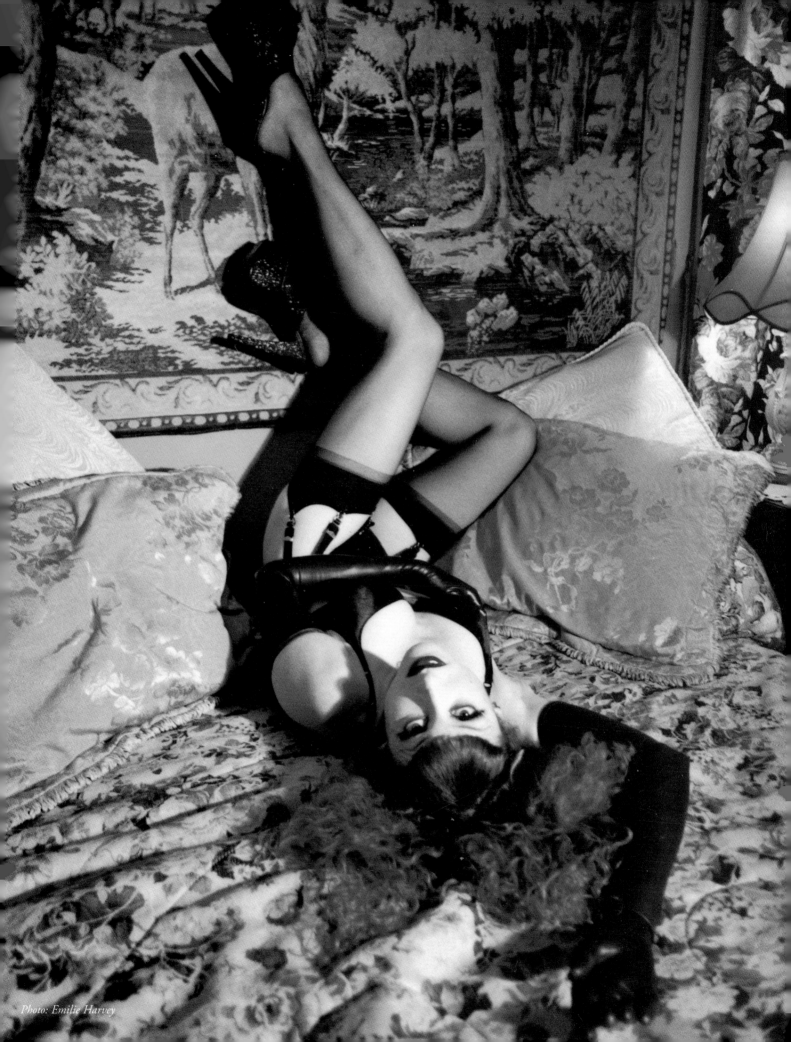

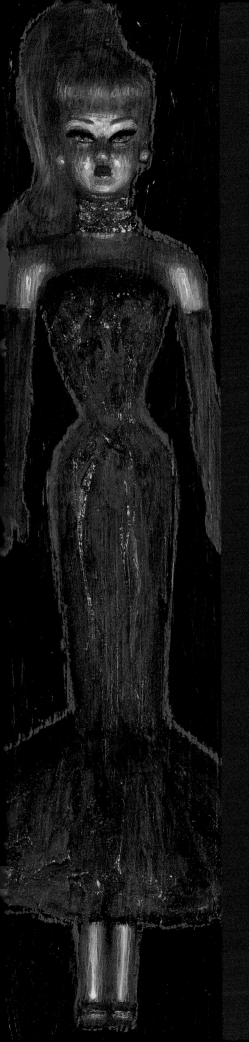

"The box, sent by the gods to Pandora, which she was forbidden to open and which loosed a swarm of evils upon mankind when she opened it out of curiosity..."

Webster's Dictionary

These paintings arose out of my accidental discovery several years ago of an art book called "IDOLS OF PERVERSITY: Fantasies of Feminine Evil in Fin-de-Siecle Culture" by Bram Dijkstra. The book deals with the Victorian obsession with voluptuous allegorical evil women who suck the life blood out of men — the vamp, from vampire — who would steal men's vital essences and cause their demise.

My fascination with the Victorian painters' portrayal of the evil feminine has led me to plug the modern people I know into these mythological roles, hoping to spark something deep within the viewer's unconscious. The characters in my portraits have also been compared to the incubus and succubus — sexual demons which appear in people's dreams and rape them. I paint my subjects with the hope that they will have a powerful psychic sexual "charge" for the viewer.

Although these Victorian images were created by men, and produced during a time in history when female sexual power was most reviled and considered suspect, I love these depictions and see them as very powerful. Certainly the feminist era has completely revolutionized our roles in the world, but I think it has thrown the baby out with the bath water as well. The Victorian voluptuous destroyers were some very strong images of the feminine, and I'm glad to see more and more women today producing "cultural artifacts of a sexual nature," to quote Lisa Petrucci. Artists such as Christine Karas, Isabel Samaras, Niagara, and Lisa Petrucci are the next step in the evolution from Judy Chicago's Dinner Party.

Since graduation from art school in the 1980's I have been disillusioned with the 20th century modernist tradition and have wanted to create work which would really reach out and grab the average viewer — not necessarily the person with the academic art school vocabulary to decode the work.

I think we are living in an exciting period in art history — this fin-de-siecle. Breaking from an entire century of art designed to alienate the average non art-educated individual, the art-of-the-vernacular movement is growing in momentum, spearheaded by Robert Williams, whose own reworking of 19th century heroic allegorical painting first knocked my socks off in the mid 1980's, and Billy Shire, La Luz de Jesus' visionary creator and collector.

In the 19th century people went to see paintings the way people today go to see a blockbuster movie like Titanic. To create art that is as direct, engaging, and accessible as film and music video is the driving impulse behind the new allegorical work being created today.

I have classified the paintings here into four groupings — the four elements: fire, earth, air and water. This is based on all western allegorical painting, world mythology, the tarot, and astrology for that matter — deities and themes are assigned to one of the four elements. I start a portrait by determining which quality my model embodies, and if that is not readily apparent I ask them their astrological sign, hoping that will determine which attribution they will get. Other times I paint the portrait and see what emerges after the fact.

I hope that the many souls contained herein will affect you the way they have affected me...

Stacy Lande
Silverlake, California

The artist relaxes during a typical "family-home-evening"
with Chucky, Albert and Twisselman

Photos: Emilie Harvey

\star FIRE \star

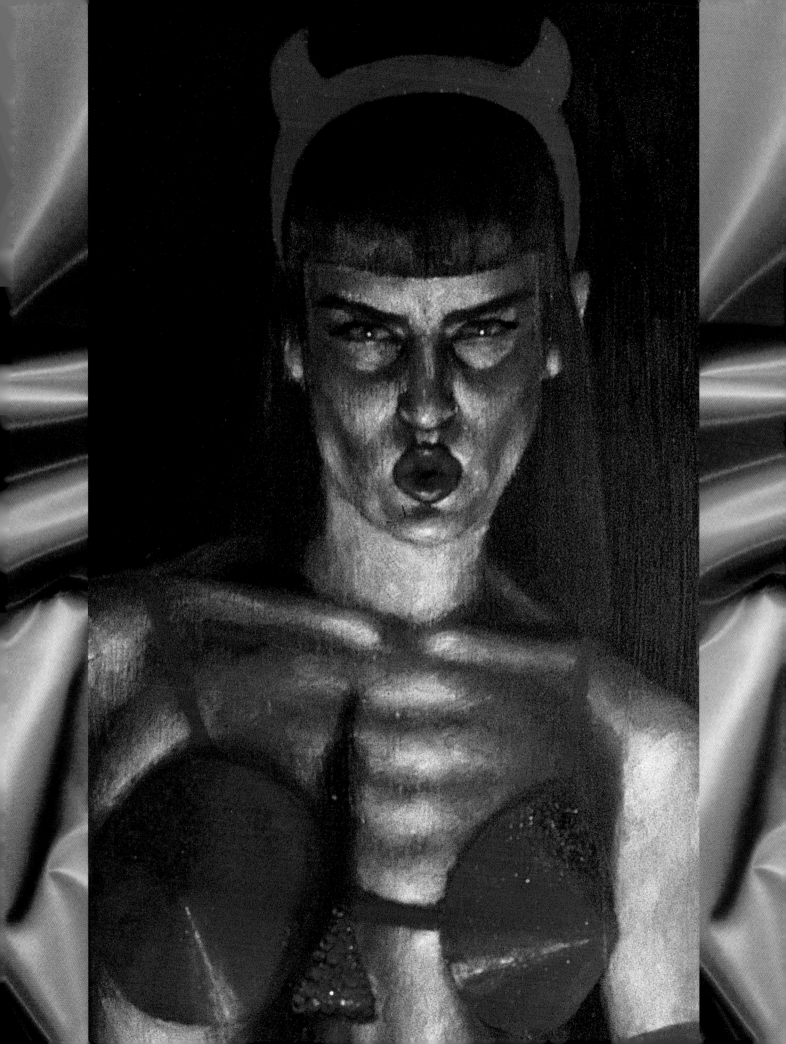

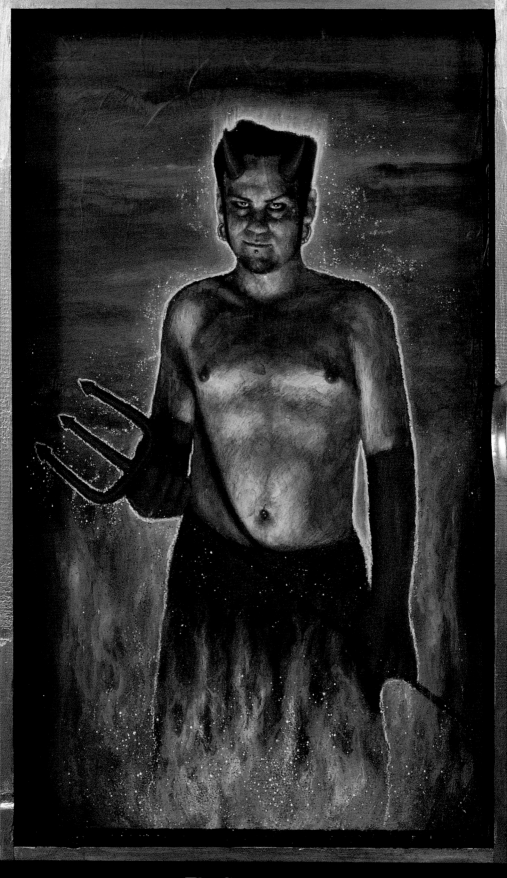

"The Superfiend"
1998, Acrylic on Wood, 41" X 25"

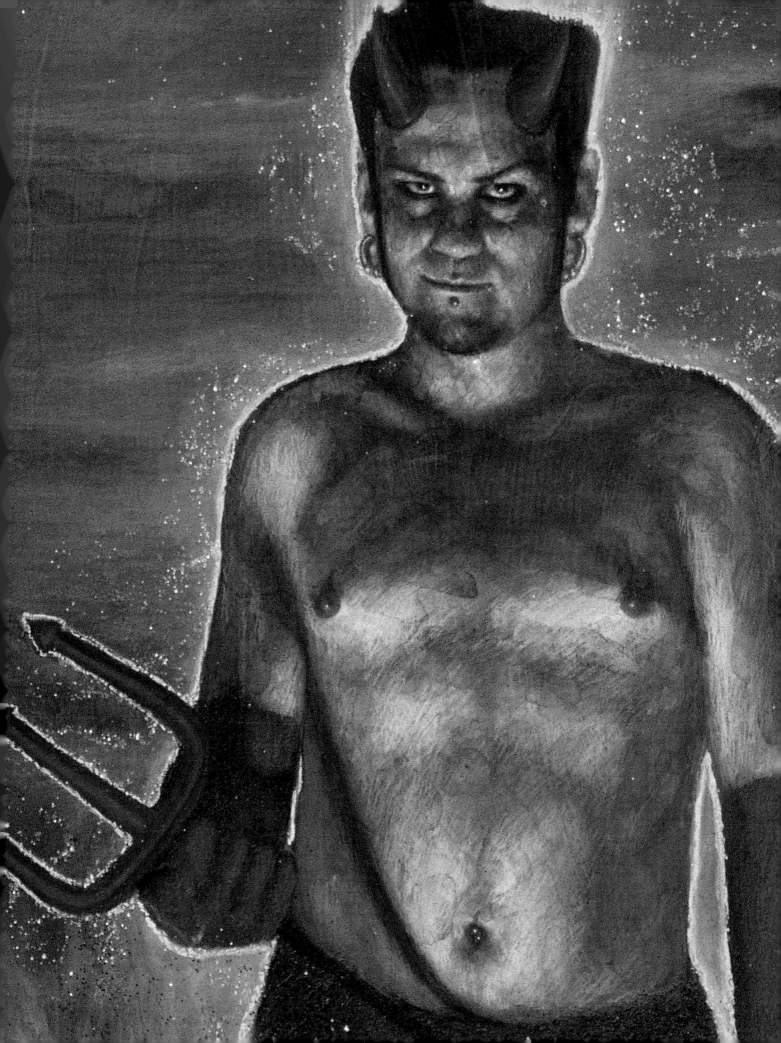

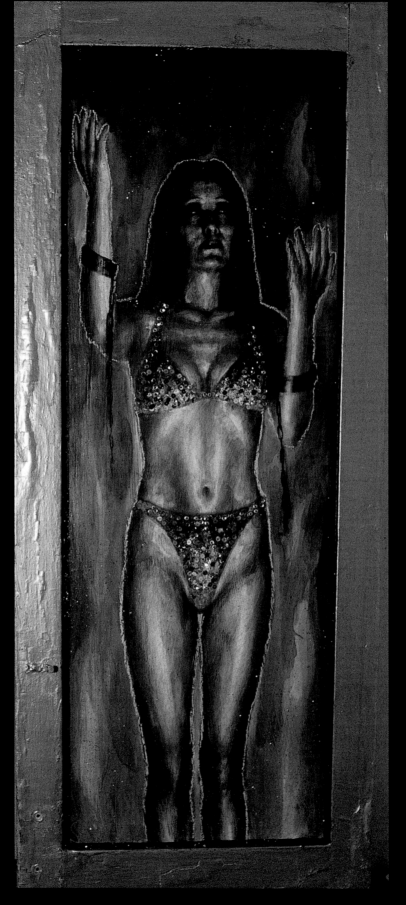

"Anima Bendita"
1998, Acrylic on Wood, 45" X 18"

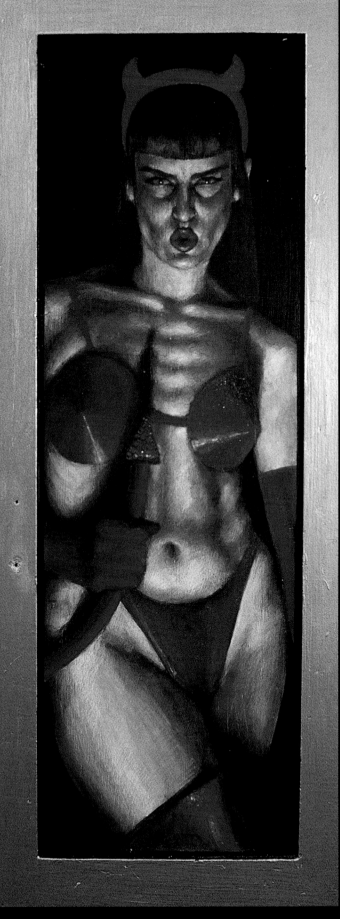

"Devil Girl II"

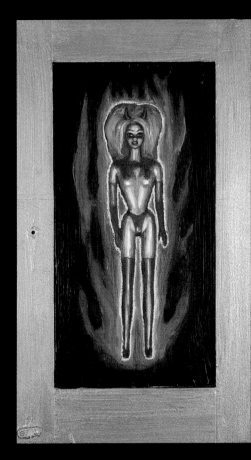

"Built-For-Sin Barbie"
1998, Acrylic on Wood, 22" X 13"

S tacy's work
reads like a photo
album from Hell..."

Lisa Petrucci

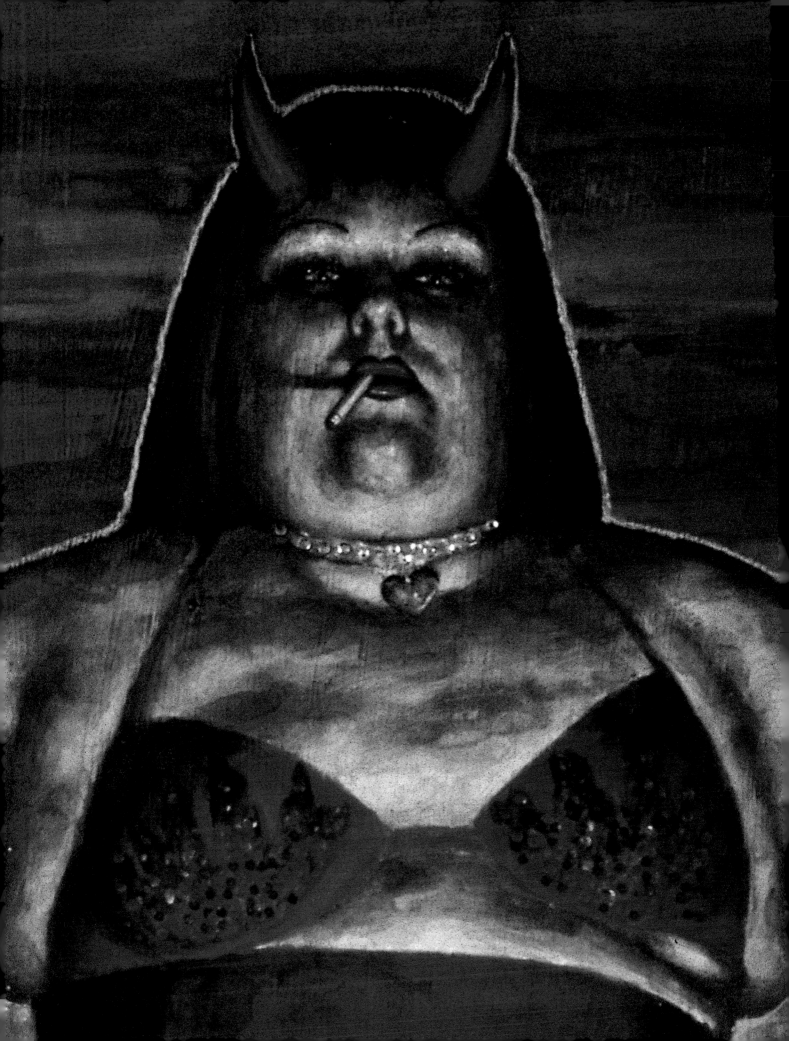

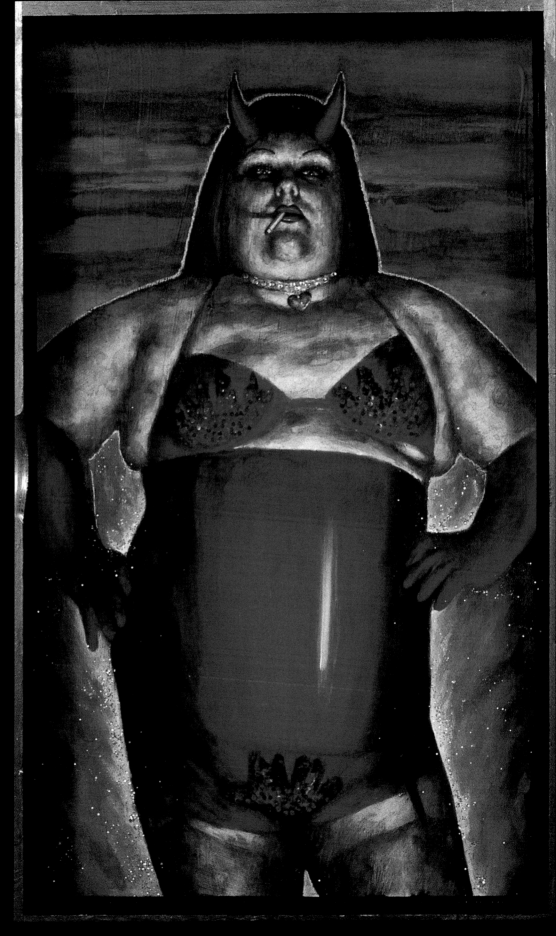

"Devil Madame"

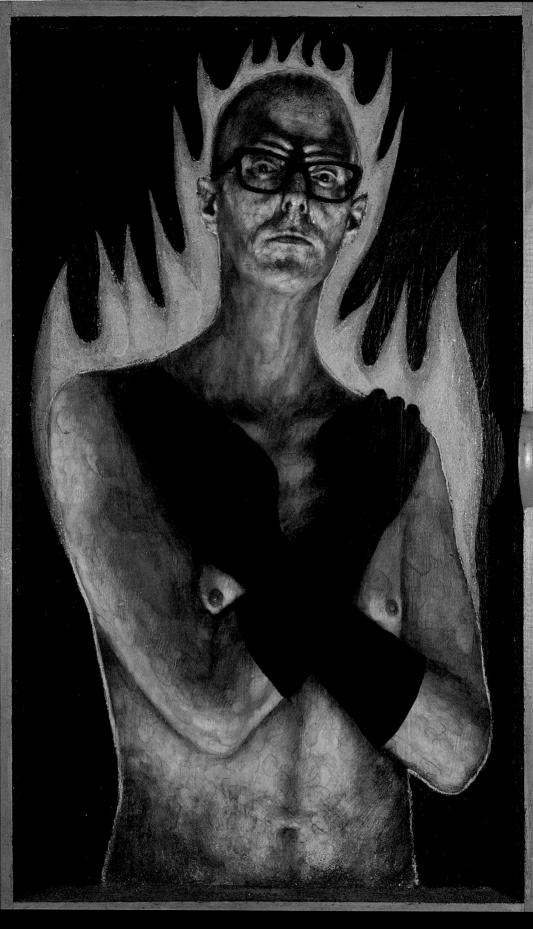

"Hades"
1997, Acrylic on Wood, 41" X 25"

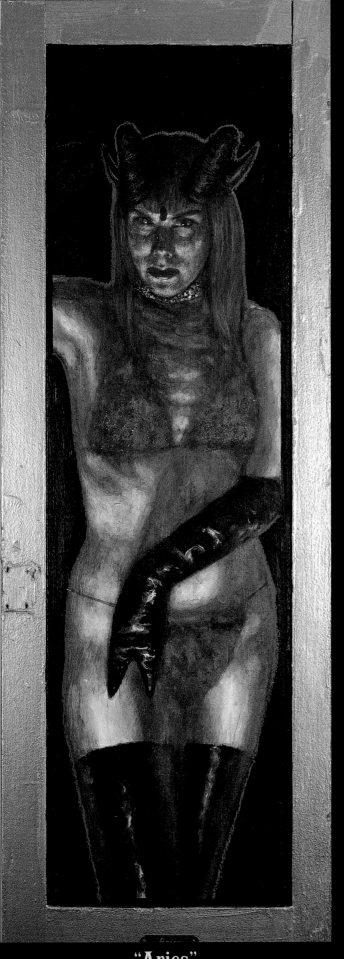

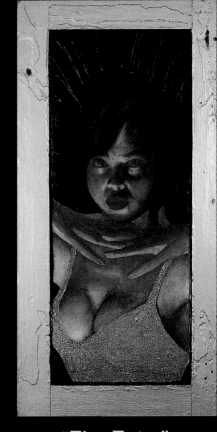

"Fire-Eater"
1992, Acrylic on Wood, 27" X 13"

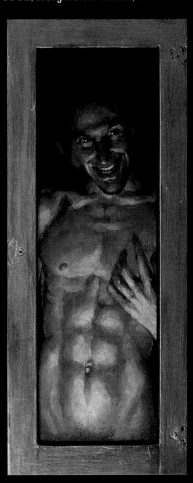

"Aries"
1999, Acrylic on Wood, 48" X 17"

"Fiery Portrait"
1994, Acrylic on Wood, 34" X 15"

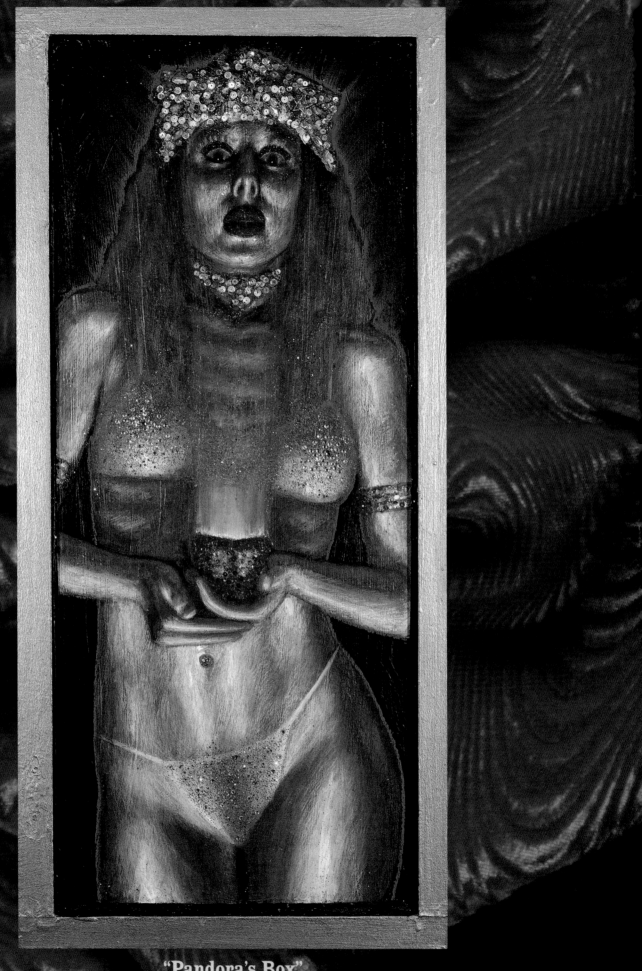

"Pandora's Box"
1999, Acrylic on Wood, 39" X 19"

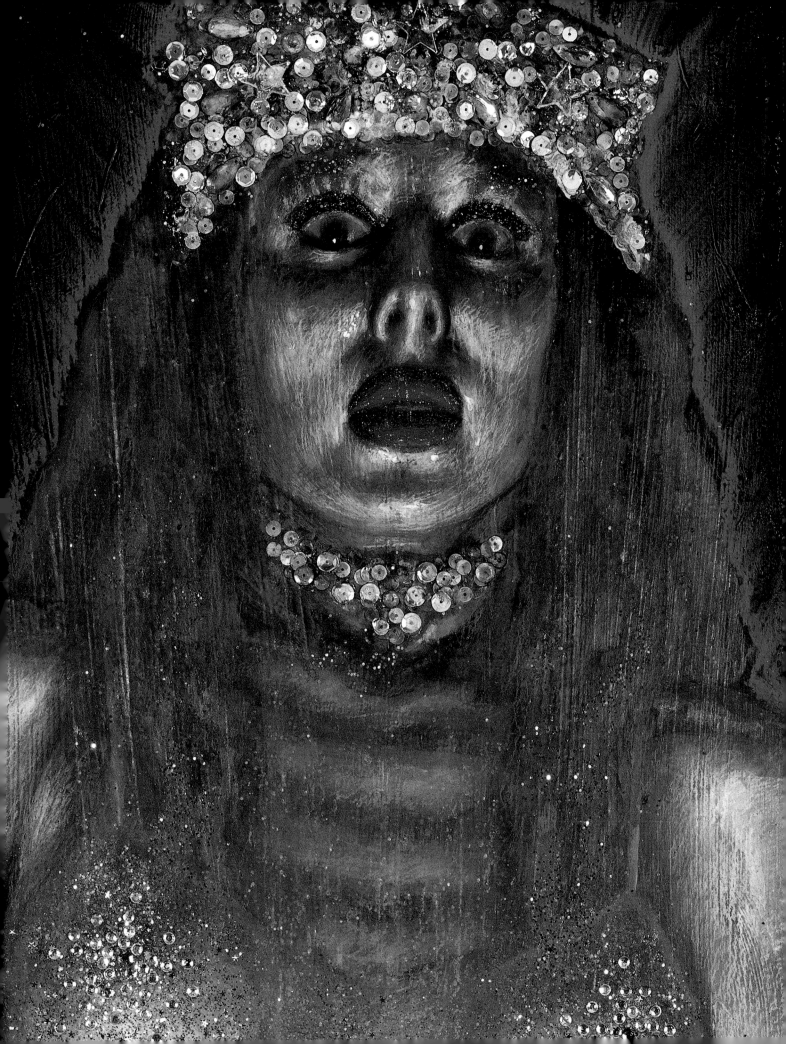

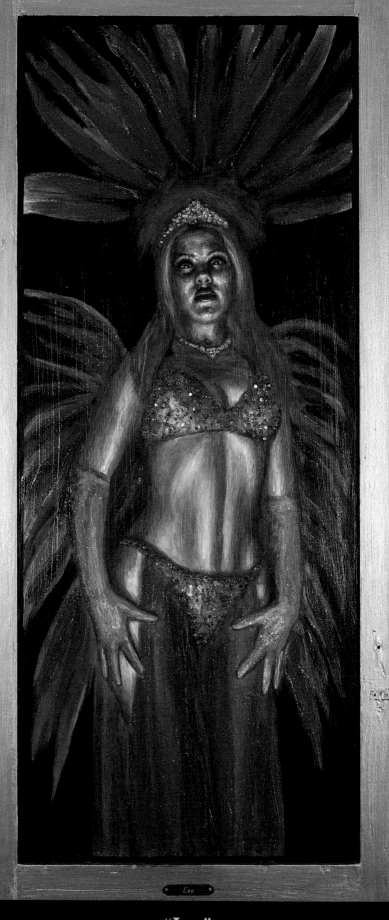

"Leo"
1999, Acrylic on Wood, 52" X 23"

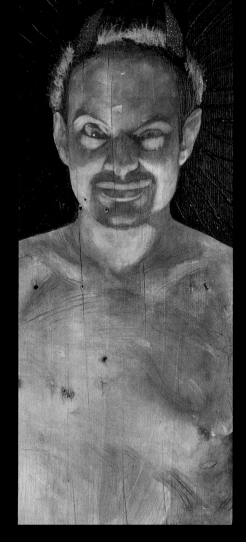

"Beelzebub's Brother"
1992, Acrylic on Wood, 30" X 11"

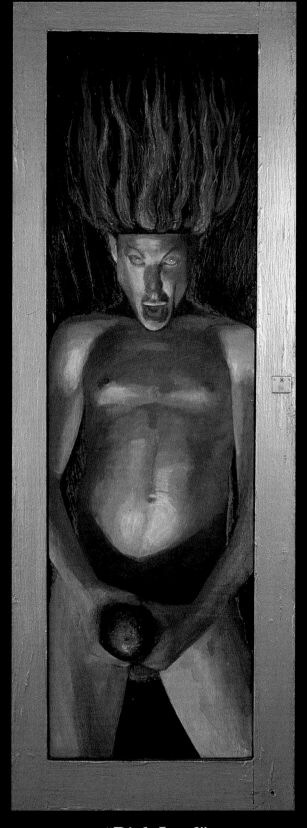

"Dick Lord"
1992, Acrylic on Wood, 43" X 15"

"*A*rt history aside, Stacy is in a league of her own, painting a sensual world that straddles flesh and fantasy, myth and modernism.."

Lisa Petrucci

35

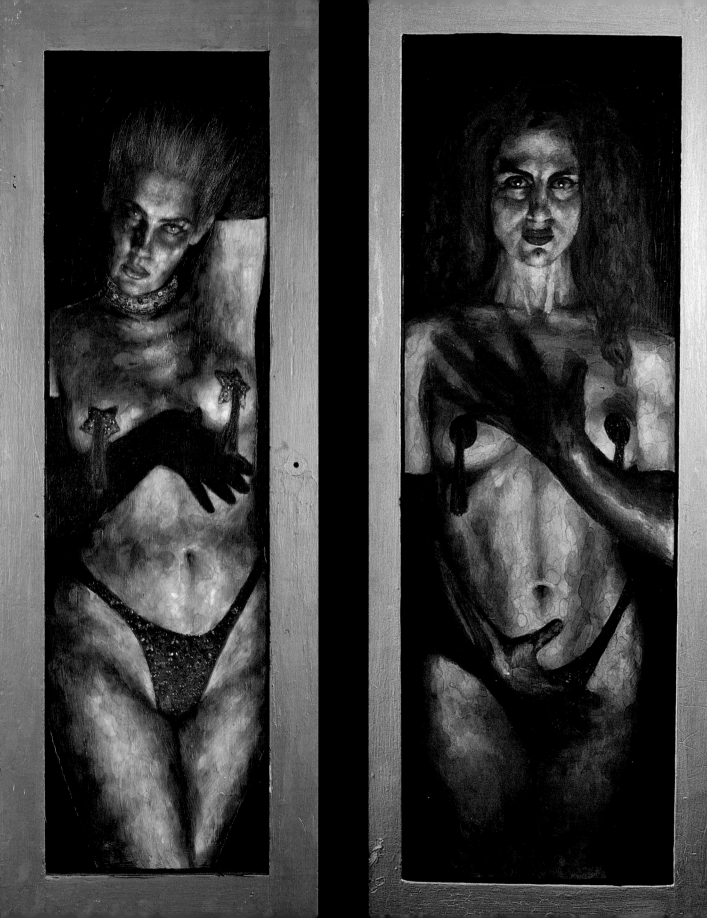

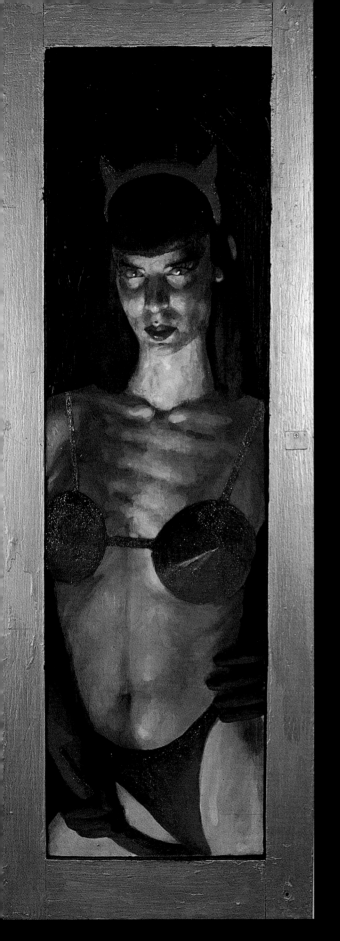

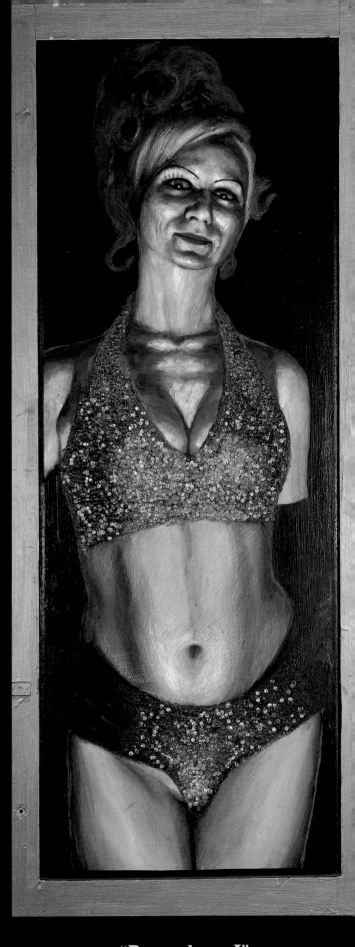

"Devil Girl I"
1993 Acrylic on Wood 43" X 15"

"Persephone I"
1995 Acrylic on Wood 48" X 19"

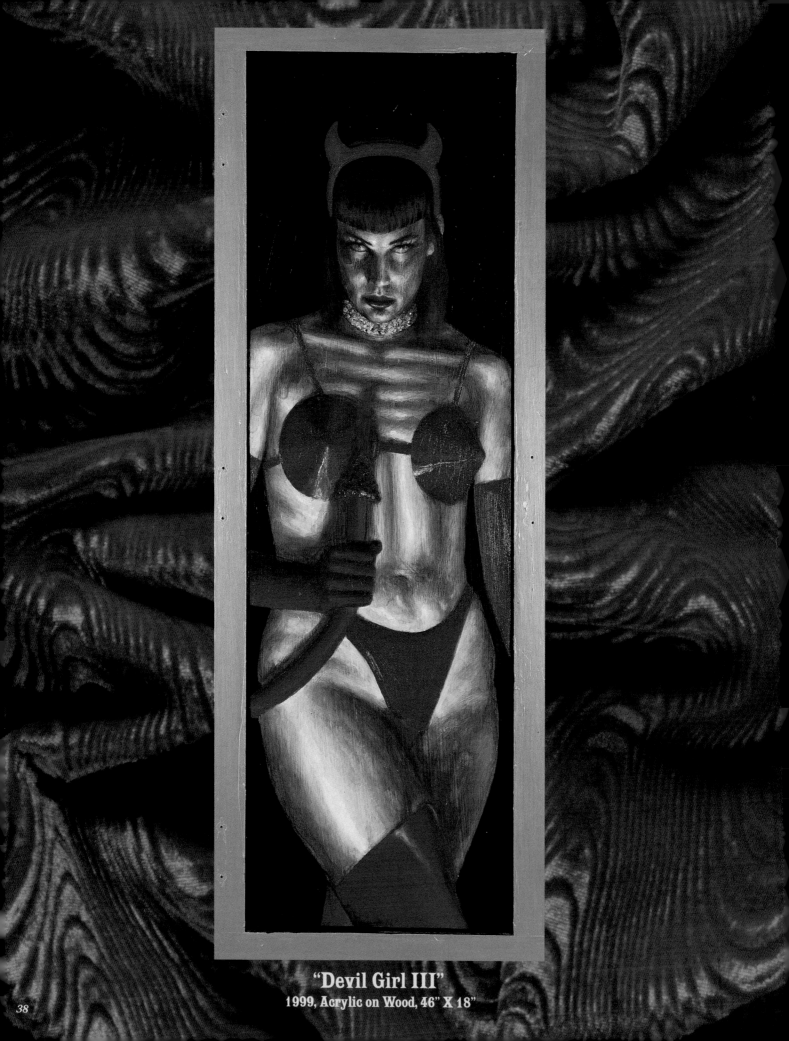

"Devil Girl III"
1999, Acrylic on Wood, 46" X 18"

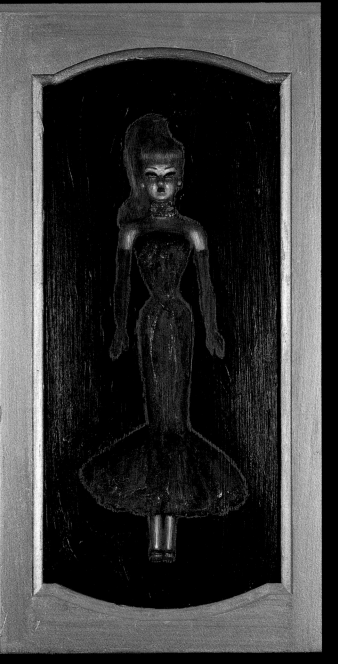

"Demeter"
1999, Acrylic on Wood, 22" X 12"

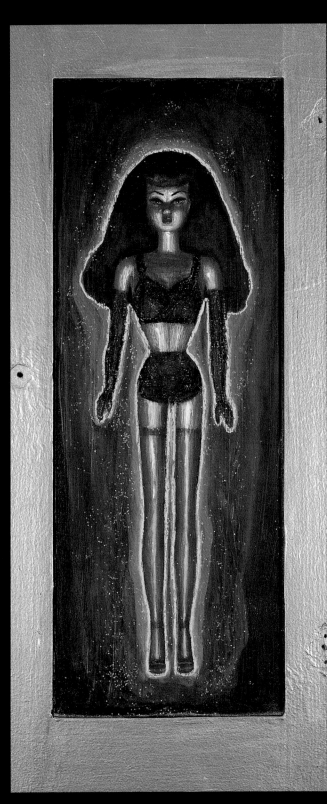

"Persephone"
1999, Acrylic on Wood, 63" X 20"

"*S*tacy invokes the vamp seductress imbued with the powers of black magic, bent on manipulating men's wills to her own self-satisfying ends."

Chris Birkbeck

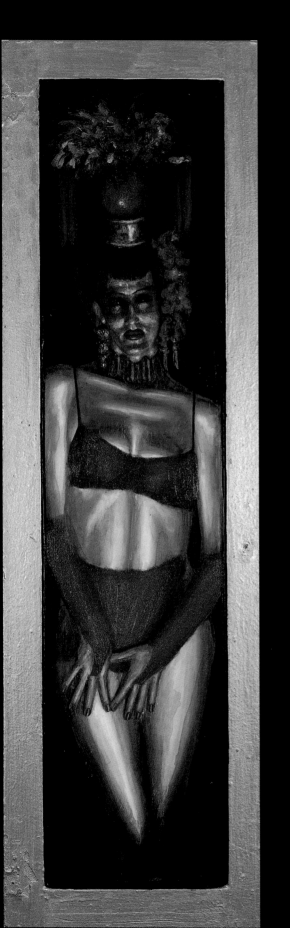
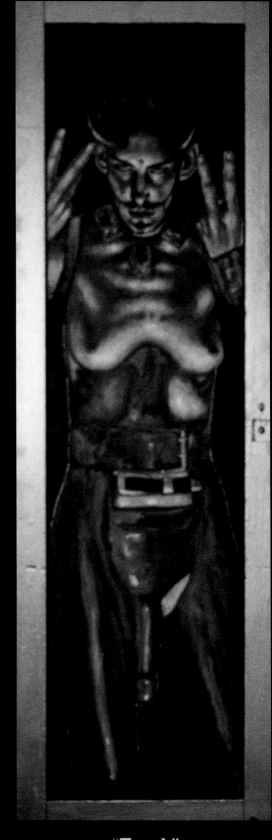

"Trash"
1995, Acrylic on Wood, 63" X 20"

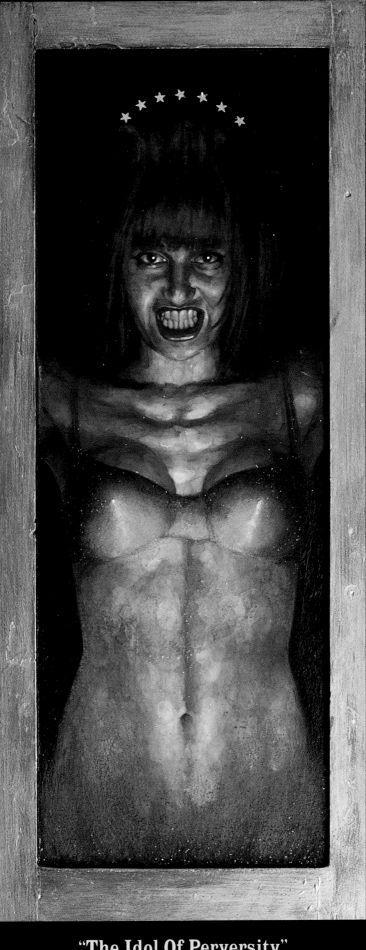

"The Idol Of Perversity"
1994, Acrylic on Wood, 44" X 18"

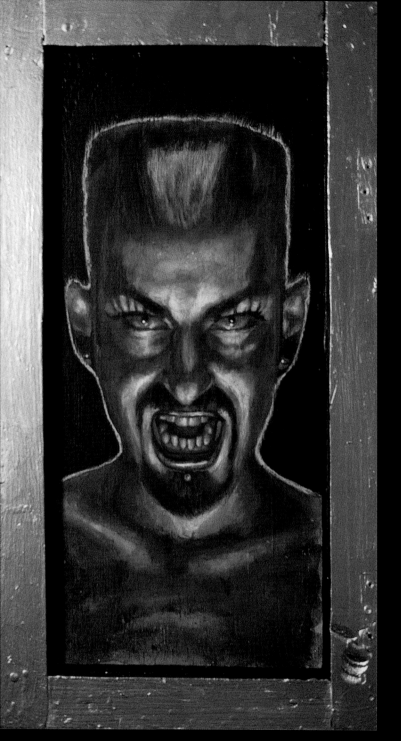

"He-Devil"
1995, Acrylic on Wood, 25" X 13 1/2"

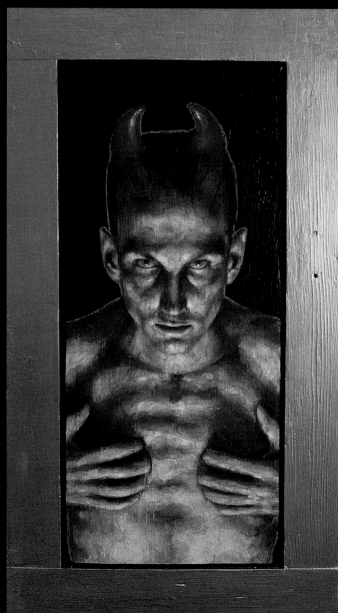

"Horned Portrait"
1996, Acrylic on Wood, 30" X 15"

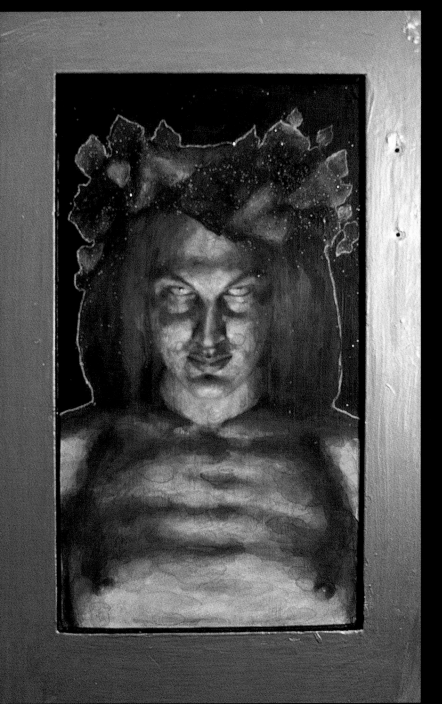

"Demon Boy"
1996, Acrylic on Wood, 26" X 16"

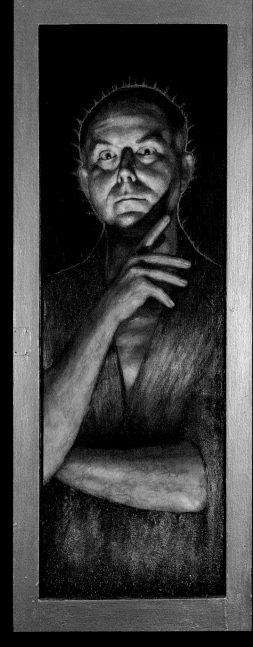

"Fire King"
(Portrait Of C. Jerry Kutner)
1994, Acrylic on Wood, 43" X 16"

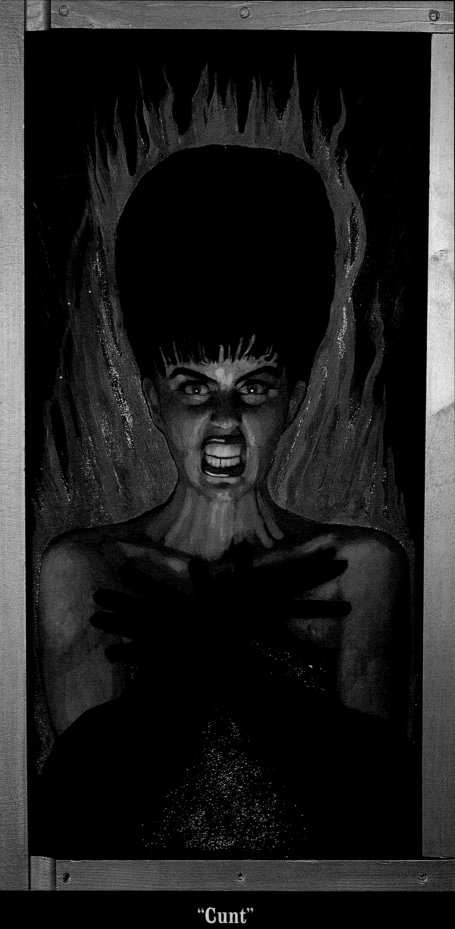

"Cunt"
1993, Acrylic on Wood, 42" X 22"

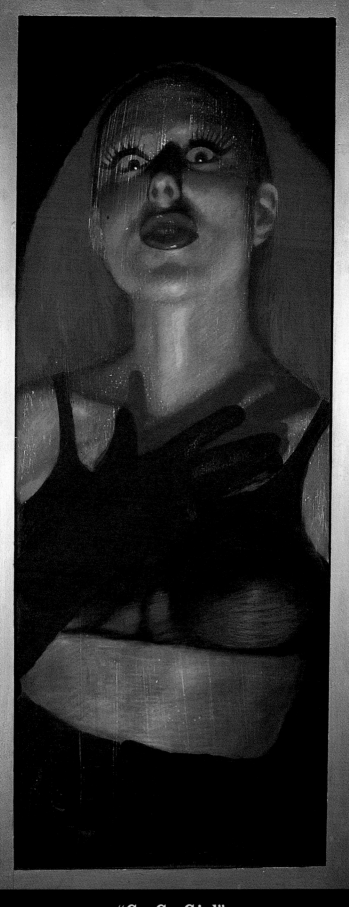

"Go-Go Girl"
1993, Acrylic on Wood, 61" X 26"

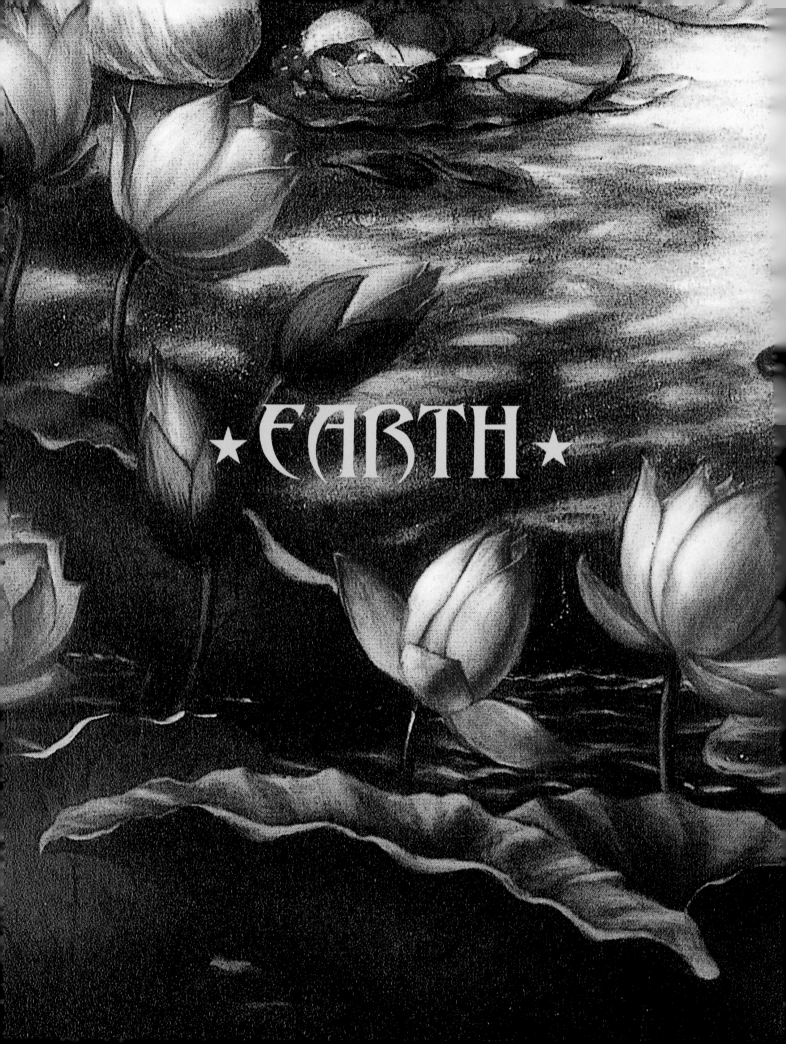

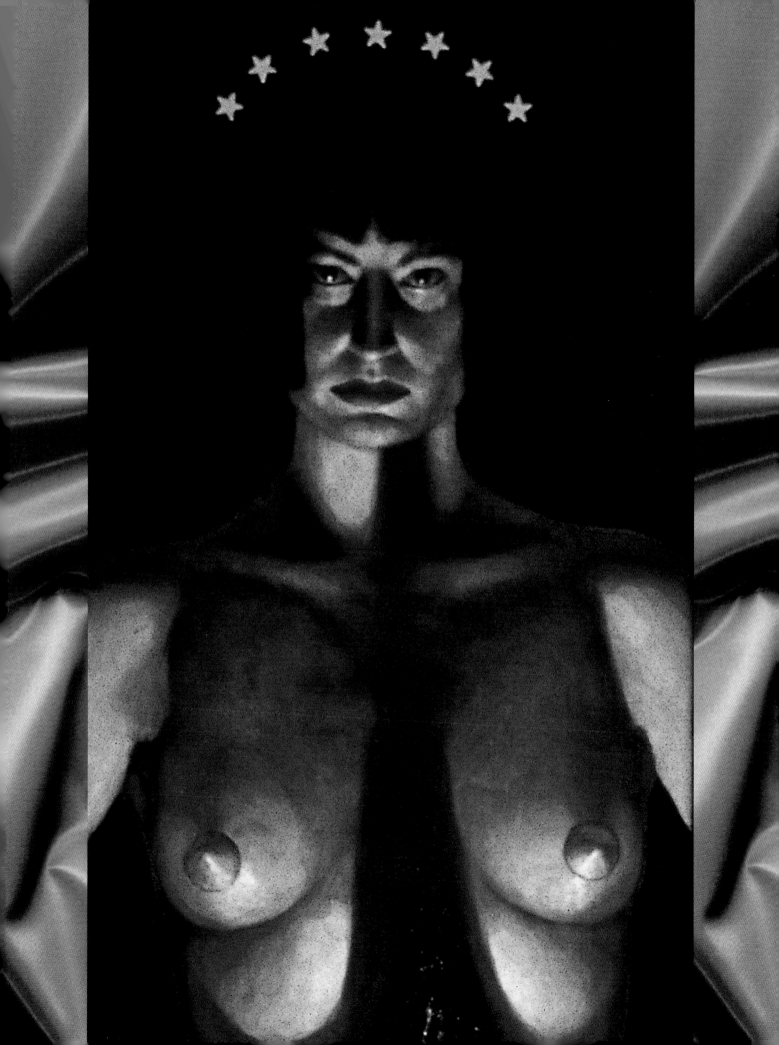

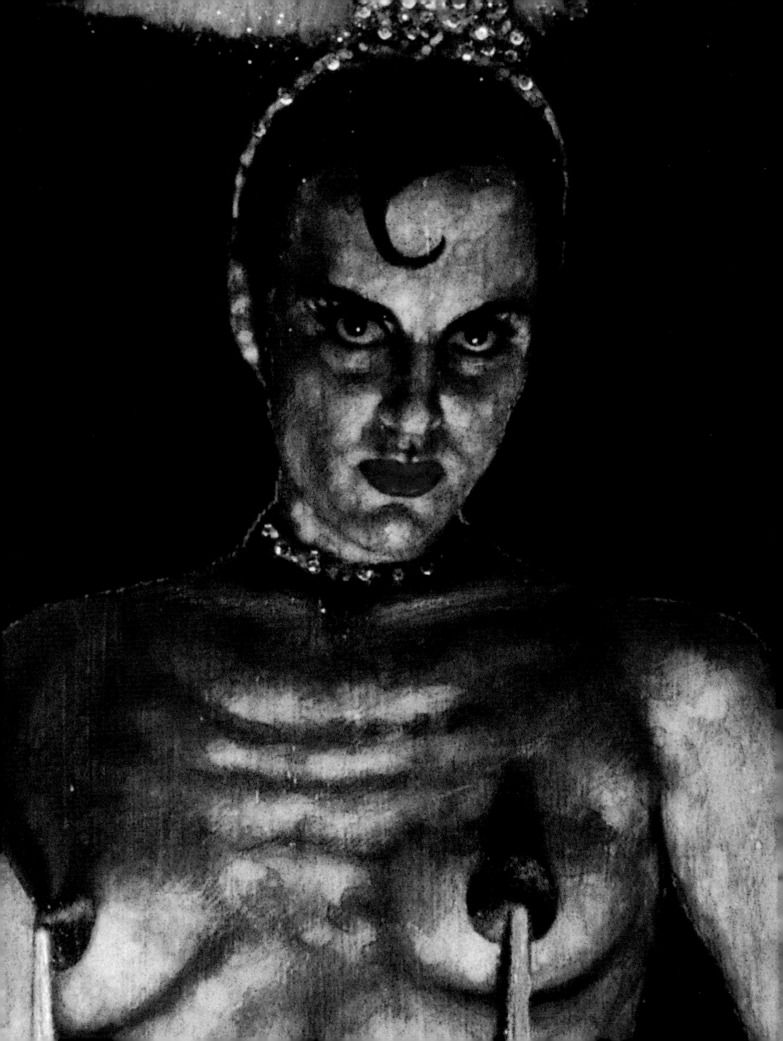

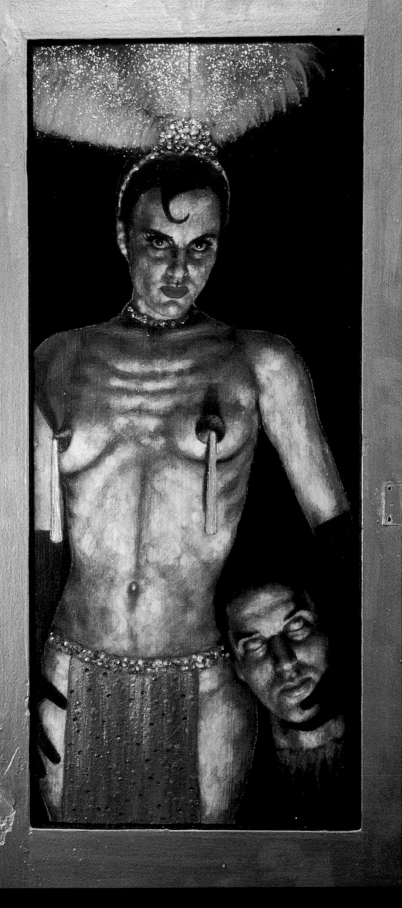

"Salome"
1997, Acrylic on Wood, 42" X 20"

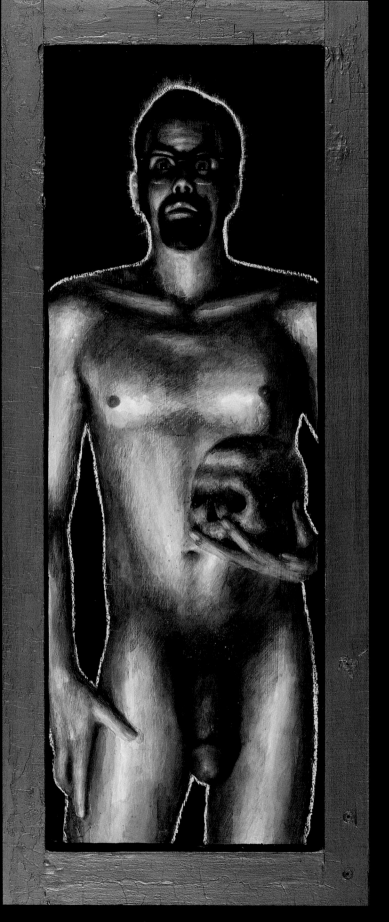

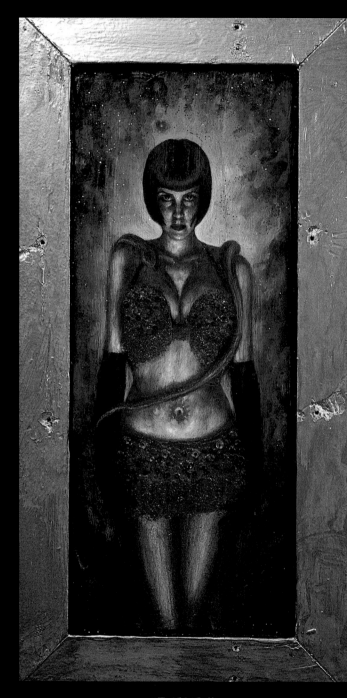

"Lilith"
1998, Acrylic on Wood, 30" X 14"

"St. Jerome"
1998, Acrylic on Wood, 45" X 18"

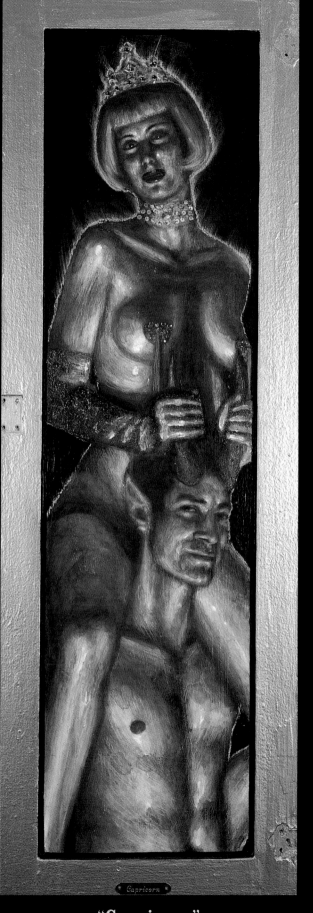

"Capricorn"
1999, Acrylic on Wood, 48" X 16"

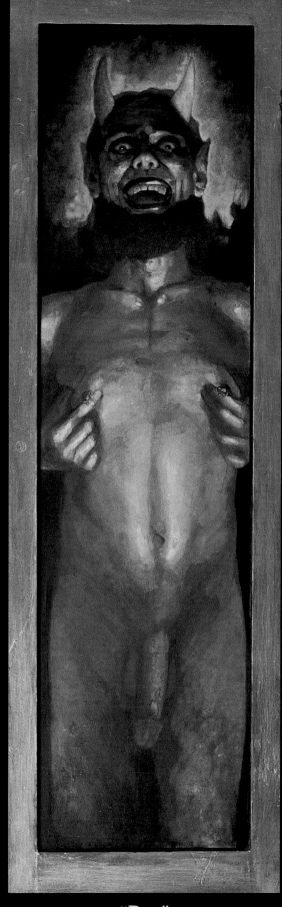

"Pan"
1994, Acrylic on Wood, 58" X 18"

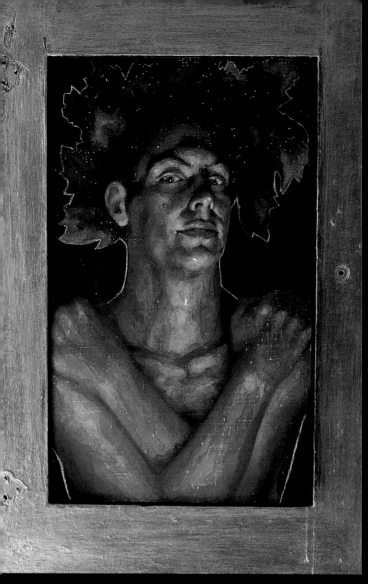

"Bacchanalian Portrait"
1994, Acrylic on Wood, 26" X 16"

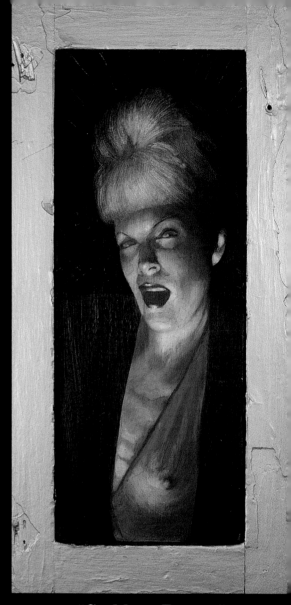

"Goddess Bunny"
1992, Acrylic on Wood, 27" X 13"

*B*e it 1890 or 1999, a Parisian Montmartre, or an Angeleno Silverlake, where ought one by chance encounter a more closely matched society of artists, writers, and musicians so decidedly intent upon displacing the edifice of dictated form?"

Chris Birkbeck

"Spirit Rod"
1993, Acrylic on Wood, 27" X 14"

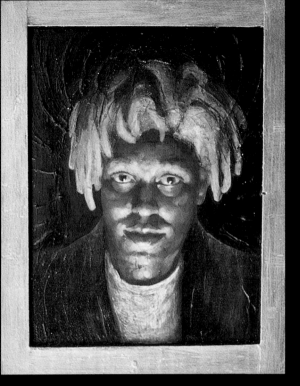

"Pastoral Portrait"
1994, Acrylic on Wood, 24" X 18"

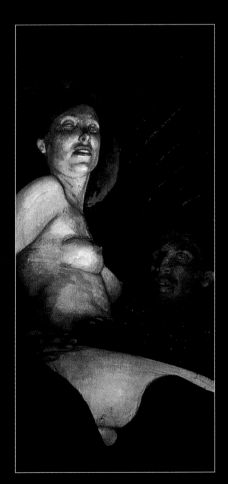

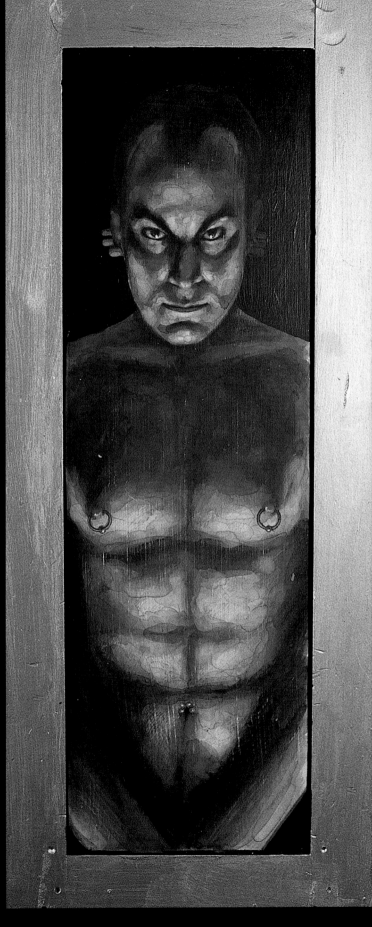

"Othello and Desdemona"
1992, Acrylic on Wood, 45" X 27"

"St. Sebastian"
1995, Acrylic on Wood, 32" X 13"

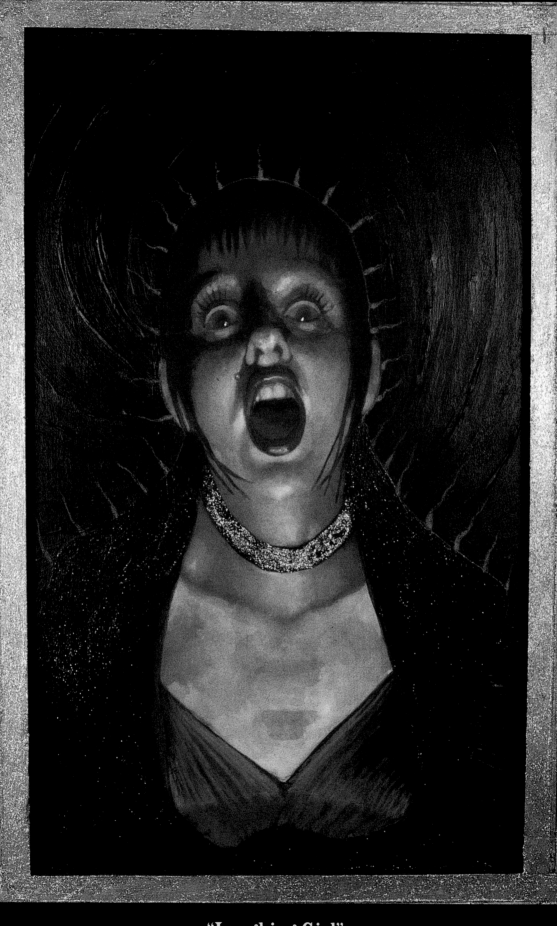

"Laughing Girl"
1992, Acrylic on Wood, 30" X 20"

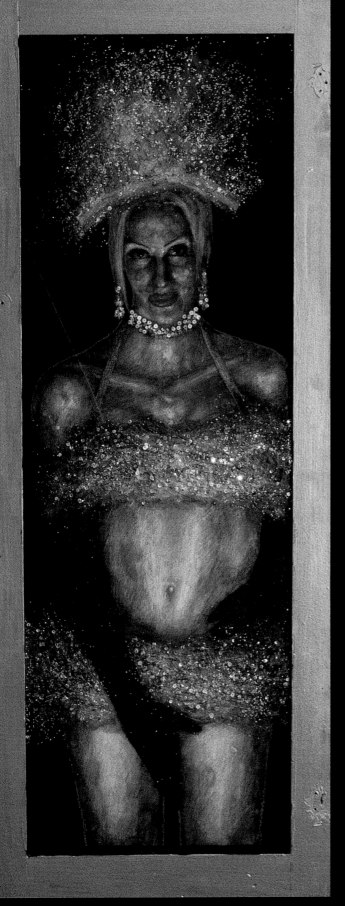

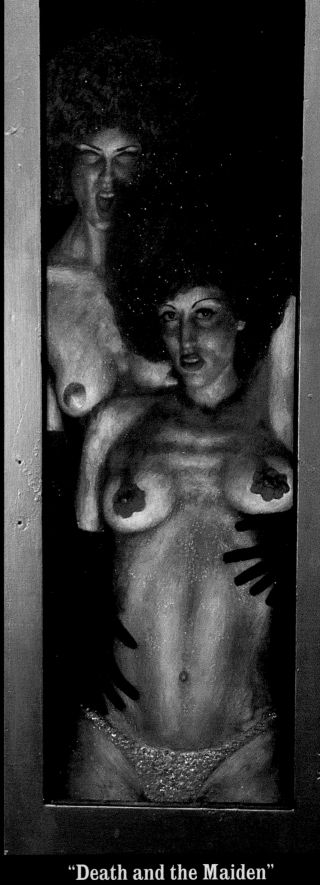

"Printemps"
1998, Acrylic on Wood, 51" X 20"

"Death and the Maiden"
1997, Acrylic on Wood, 44" X 18"

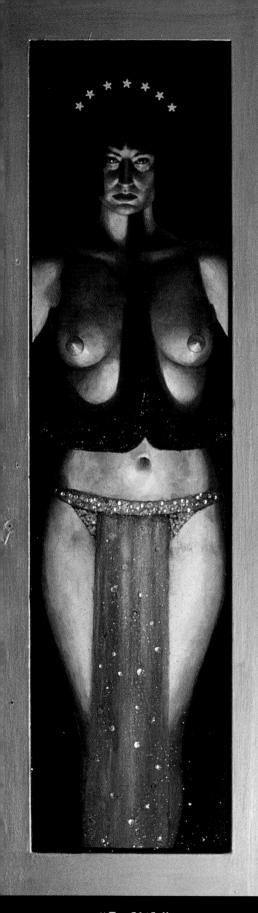

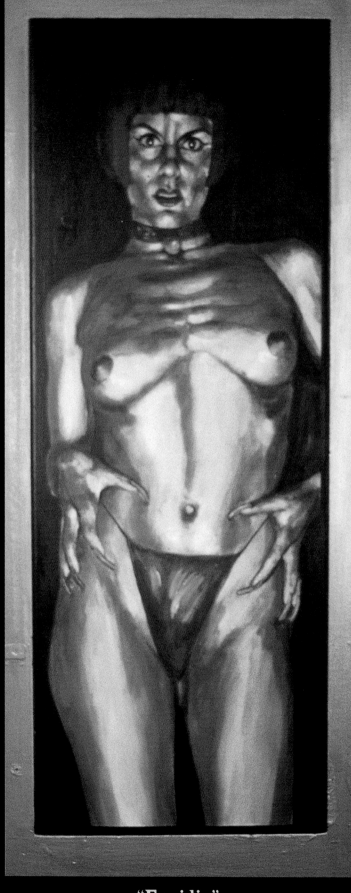

"Judith"
1994 Acrylic on Wood 50" X 18"

"Envidia"
1995 Acrylic on Wood 47½" X 19½"

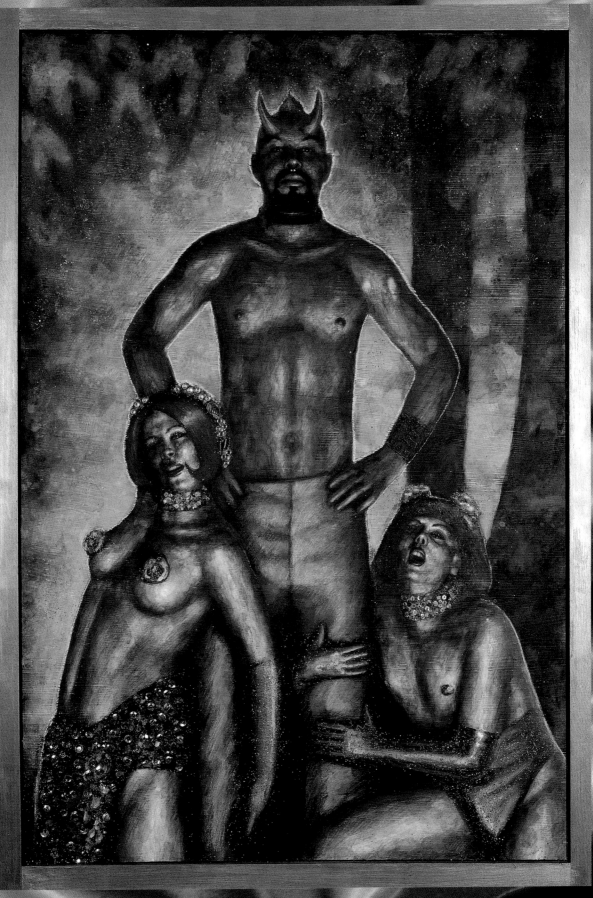

"Satyr and Nymphs"
1998, Acrylic on Wood, 46" X 32"

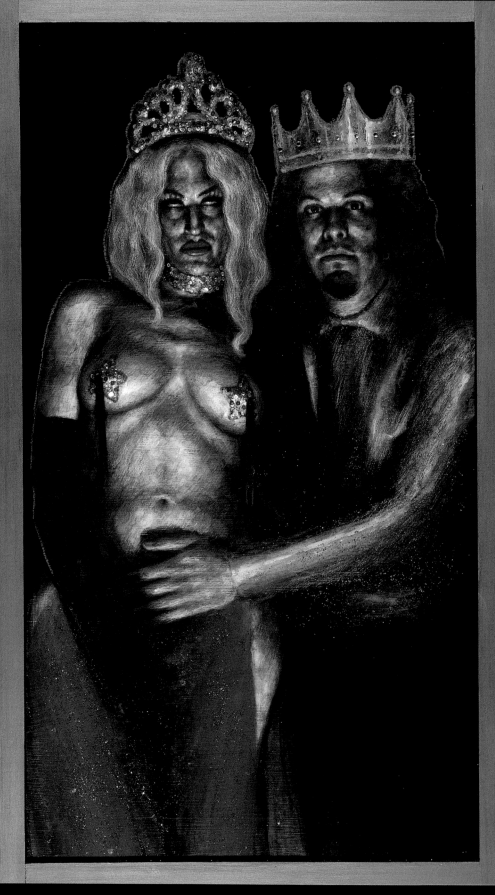

"Solomon and Sheba"
1998, Acrylic on Wood, 46" X 27"

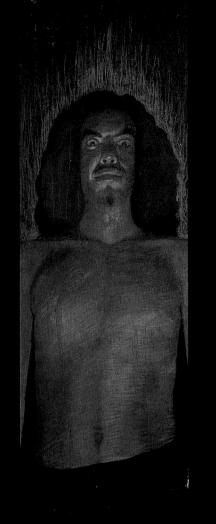

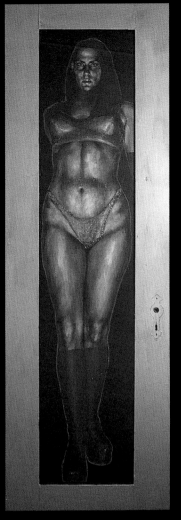

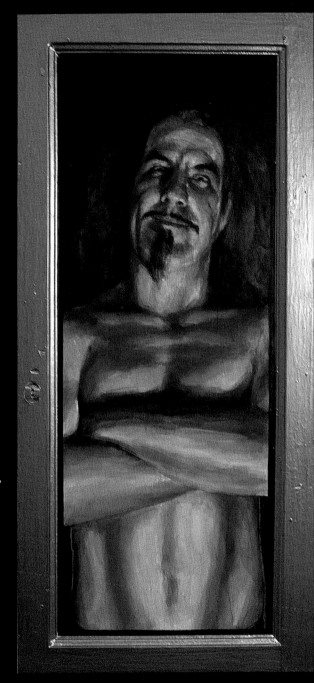

"Corn God"
1992, Acrylic on Wood, 48" X 15.1/2"

"Folly"
1995, Acrylic on Wood, 80" X 24"

"Ulysses"
1996, Acrylic on Wood, 31" X 14"

"*S*tacy celebrates the beauty in human form,
drawn from an origin unaccountable to mortal
bounds, yet physical and fleeting and earthly."

Chris Birkbeck

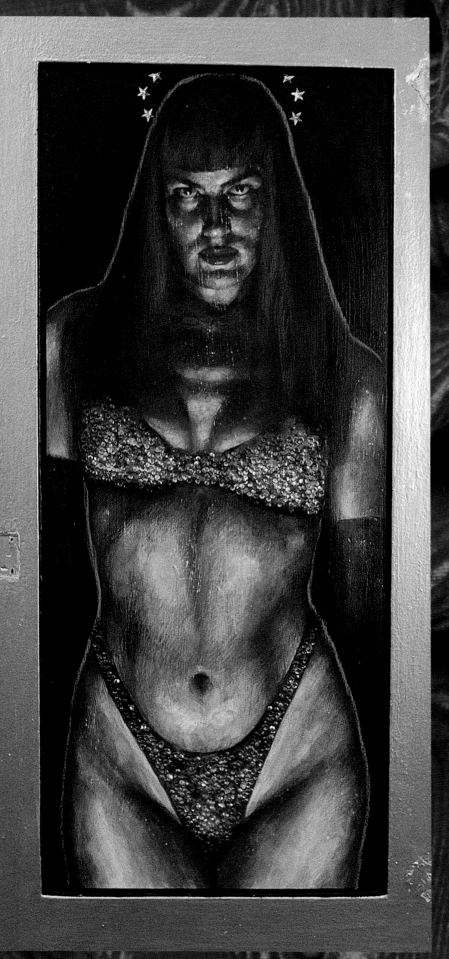

"Danae"
1996, Acrylic on Wood, 42" X 20"

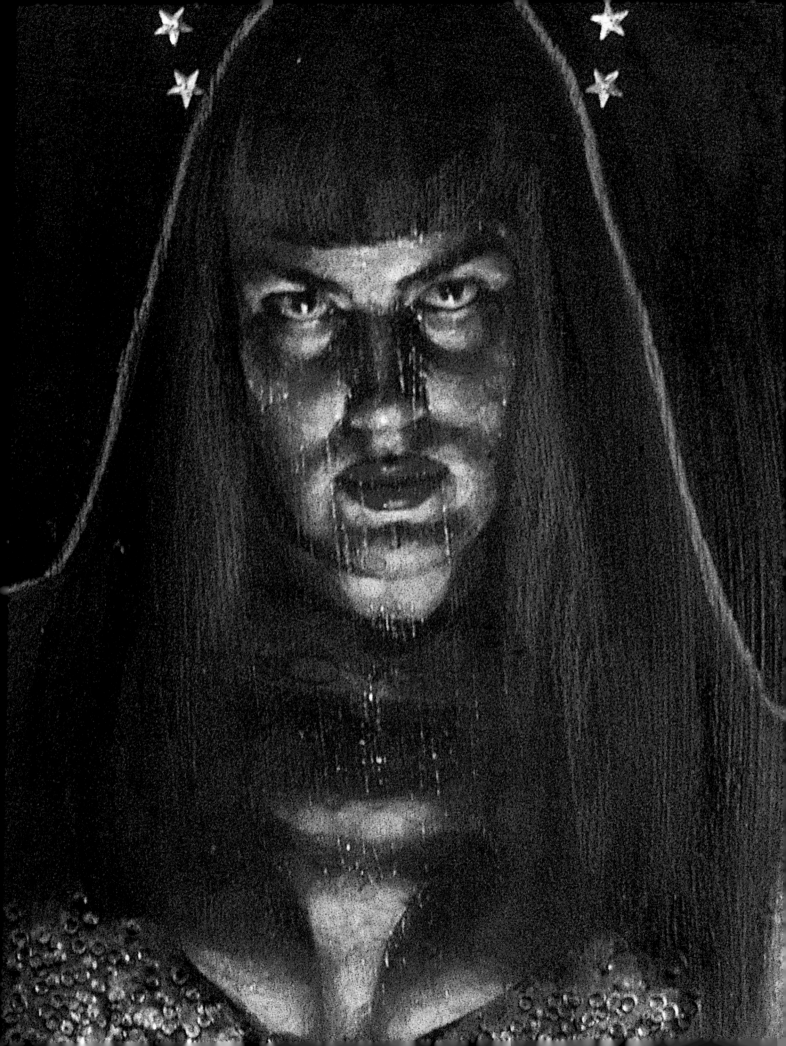

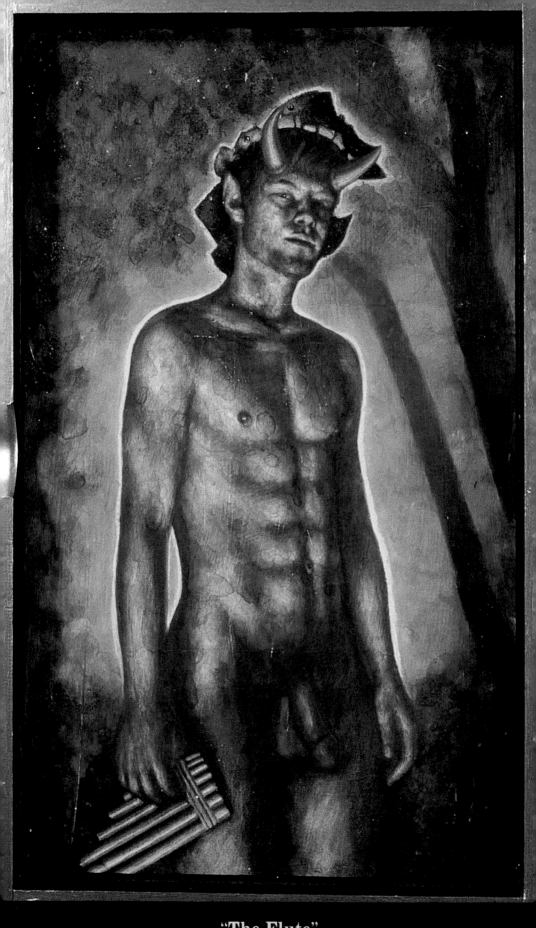

"The Flute"
1998, Acrylic on Wood 41" X 25"

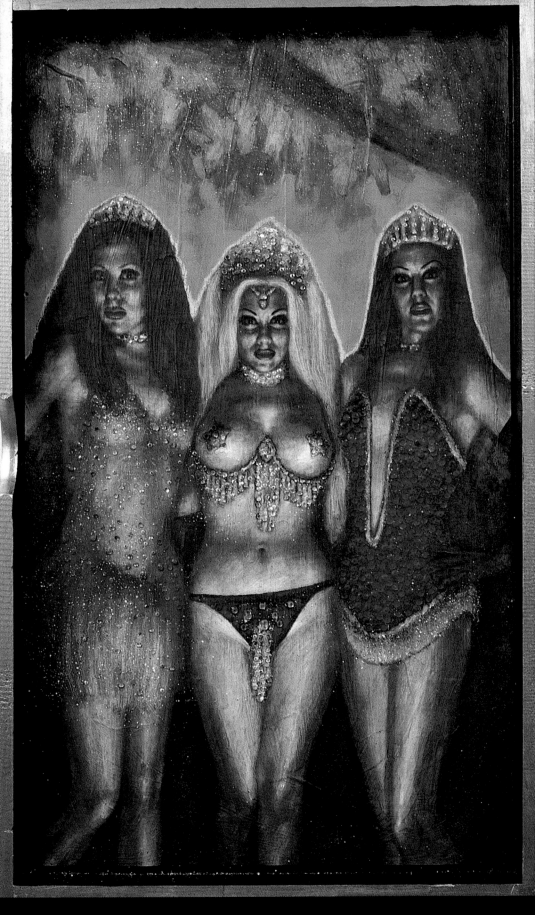

"The Three Graces"
1998, Acrylic on Wood, 41" X 25"

★AIR★

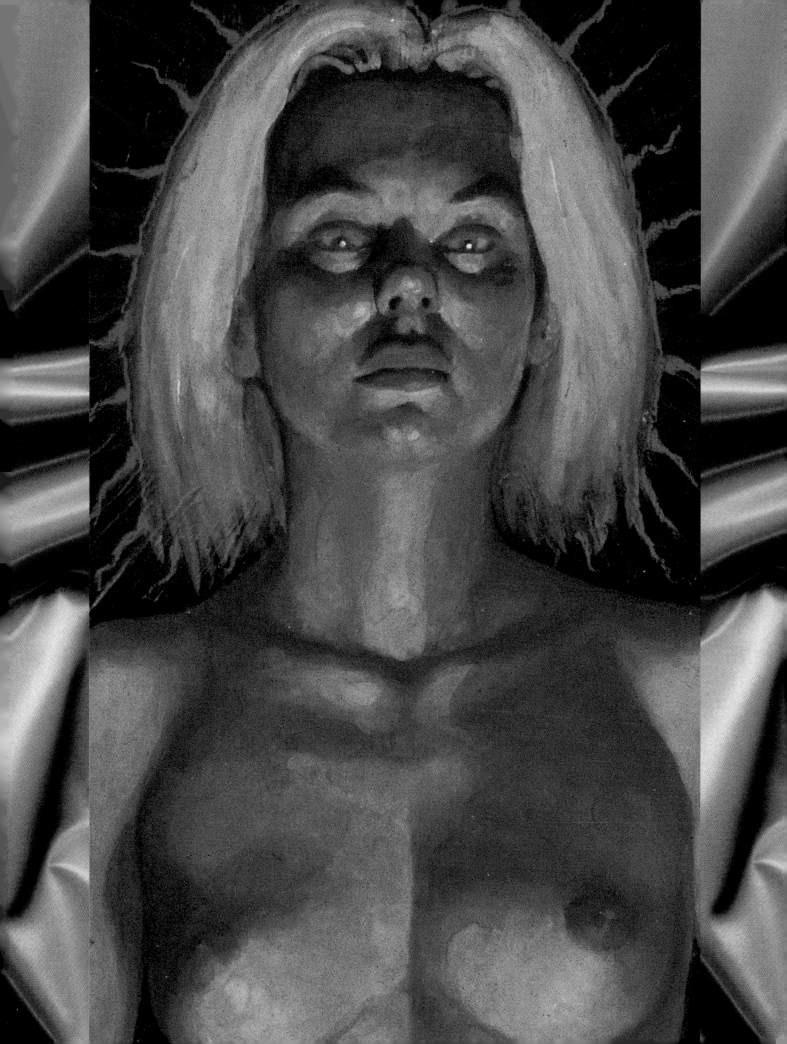

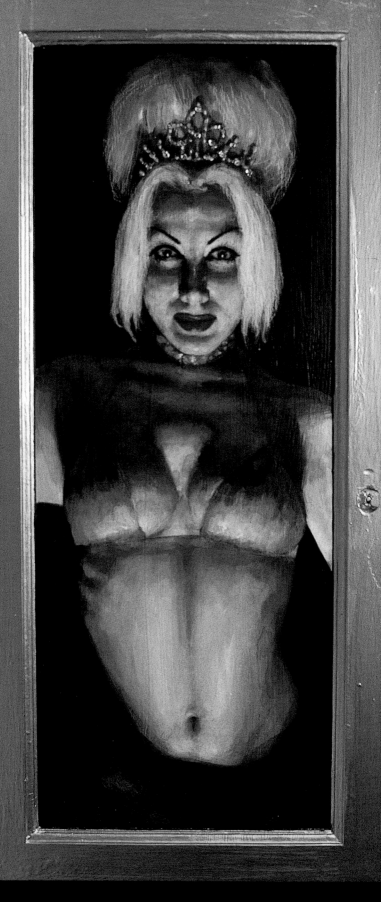

"Galatea"
1996, Acrylic on Wood, 31" X 14"

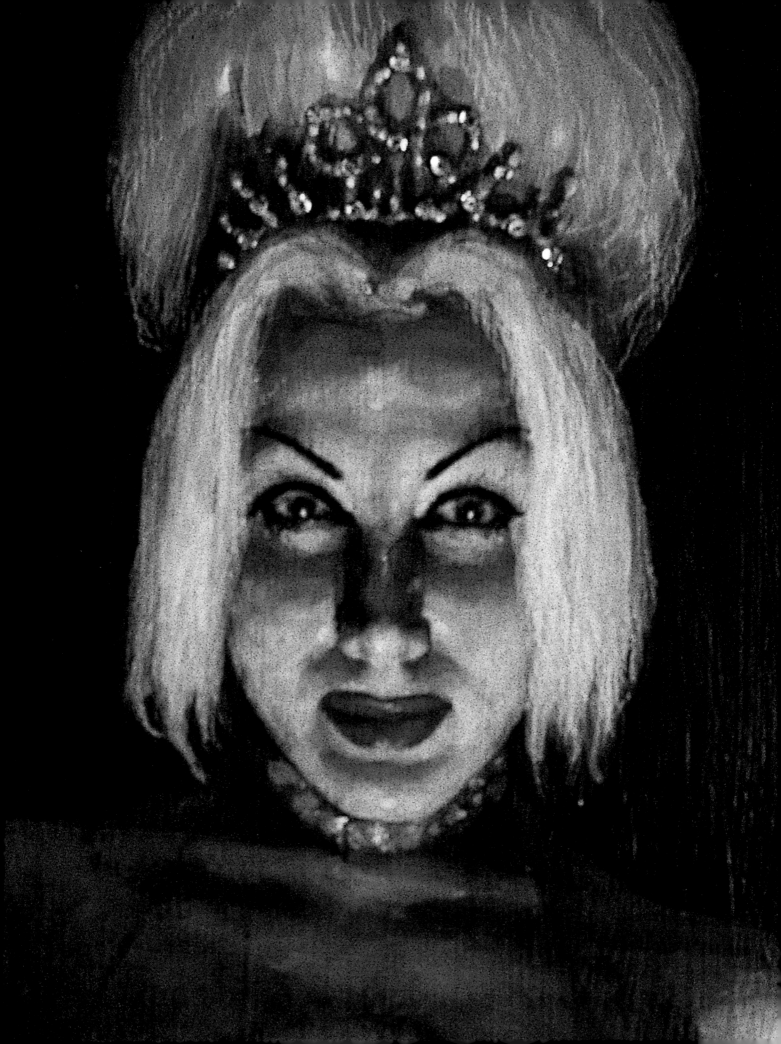

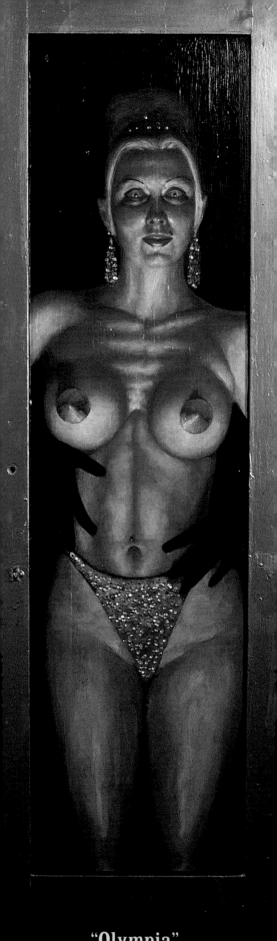

"Olympia"
1995, Acrylic on Wood, 58" X 18"

"Celestial Portrait"
1994, Acrylic on Wood, 24" X 15"

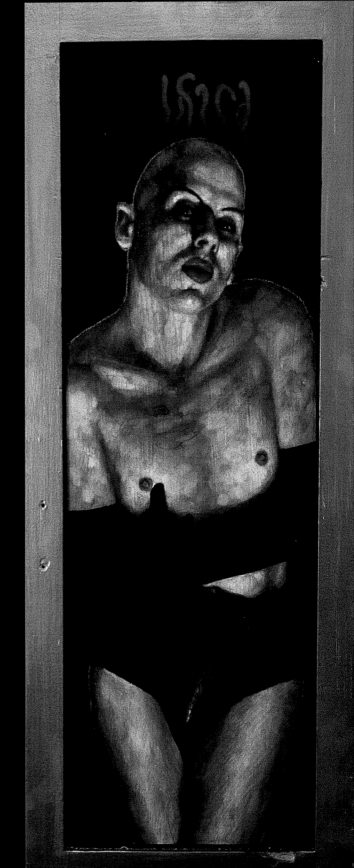

"Miss Lande's preoccupation with the Victorian period is no secret. The underside of Victorian culture has long represented what is now considered contemporary. She's all about the role-reversals that turn the tables in the appraisal of gender."

Chris Birkbeck

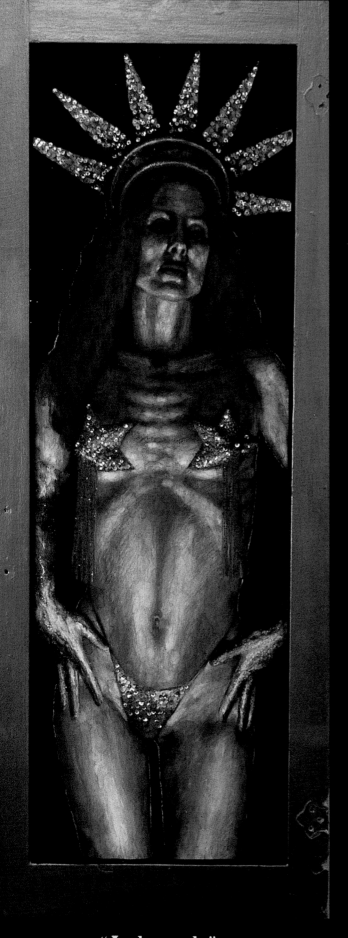

"Andromeda"

1997. Acrylic on Wood. 46" X 17"

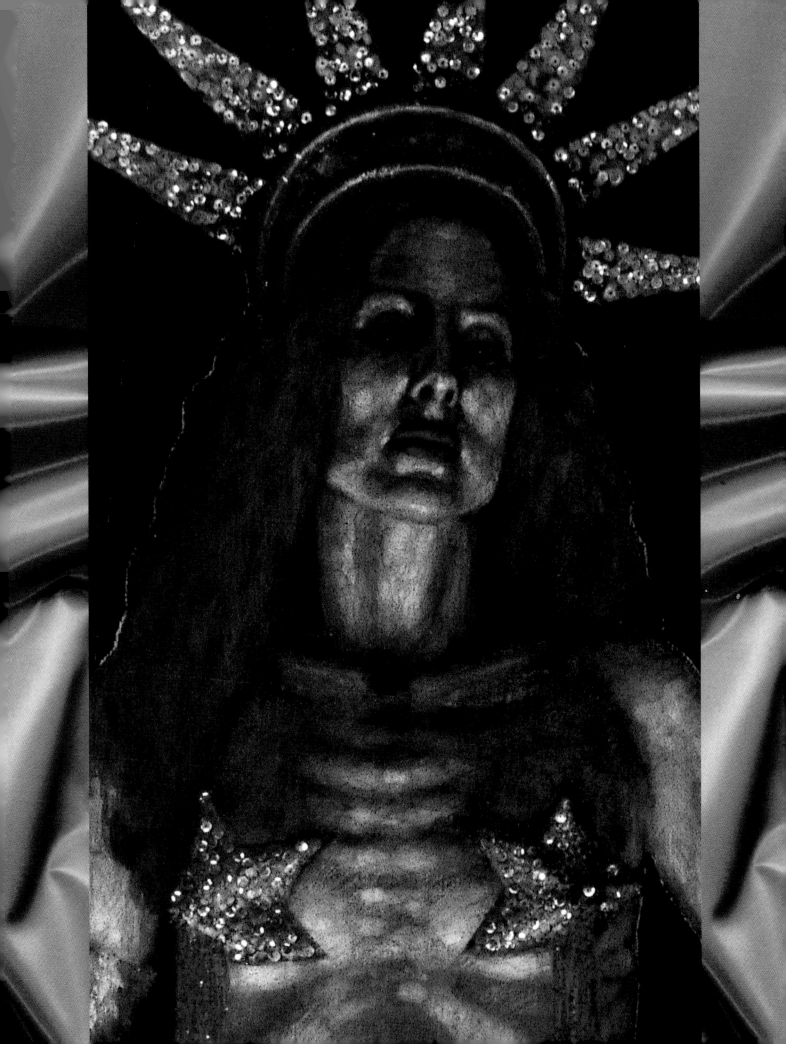

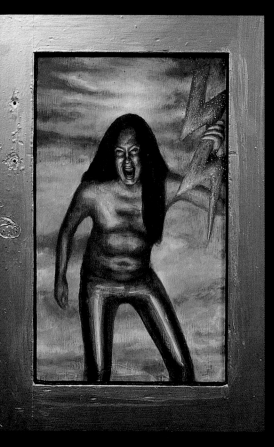

"Thor"
1998, Acrylic on Wood, 20" X 14"

" *L*ande's work
transforms 'normal'
people into symbols...
icons of power,
of sexuality, of death."

Frank Kozik

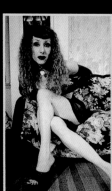

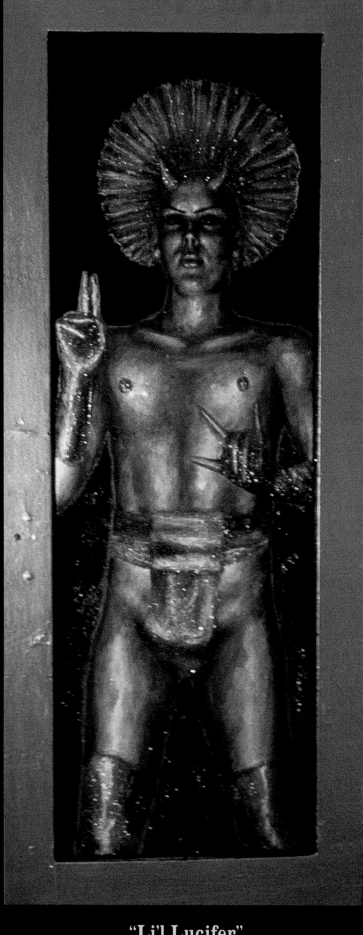

"Li'l Lucifer"
1998, Acrylic on Wood, 46" X 20"

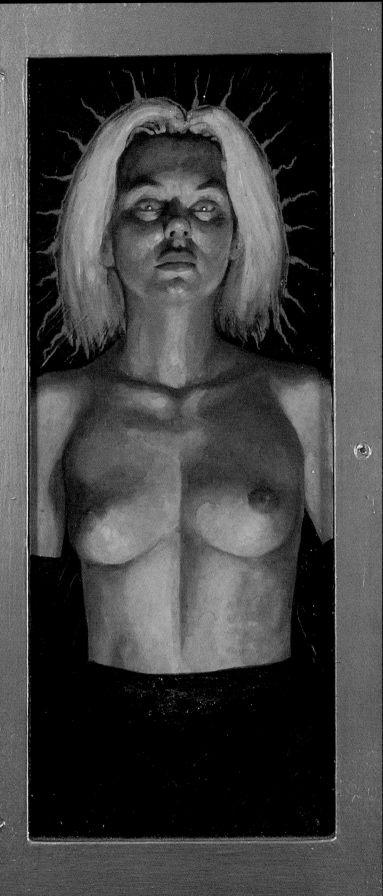

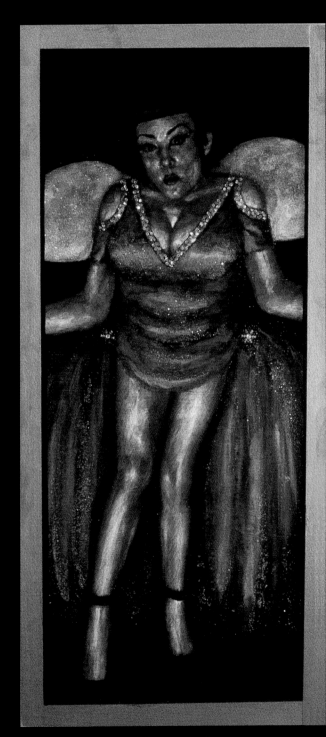

"Titania"
1998, Acrylic on Wood, 46" X 19"

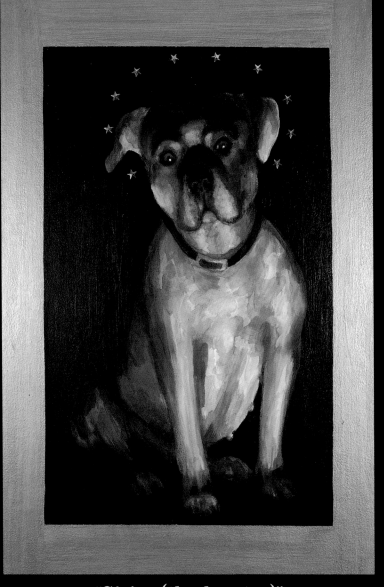

"Sirius (the dog star)"
1997, Acrylic on Wood, 36" X 24"

"Bliss-O-Rama"
1992, Oil on Wood, 18" X 15"

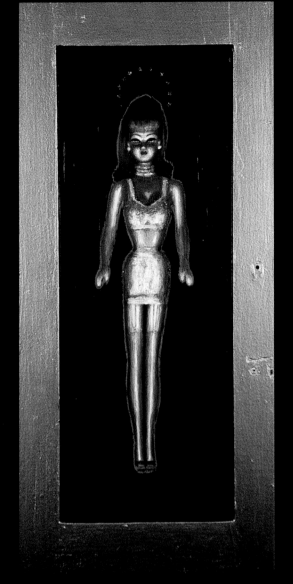

"Hera"
1999, Acrylic on Wood, 26" X 13"

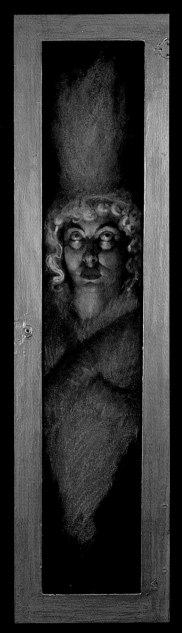

"Boopsie Girl"
1993, Acrylic on Wood, 47" X 12"

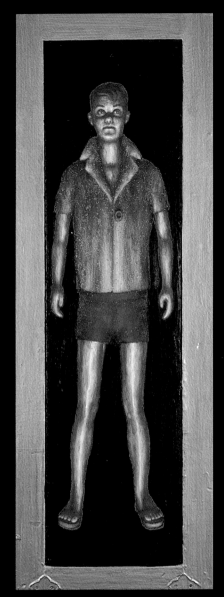

"Ken Doll"
1998, Acrylic on Wood, 32" X 13"

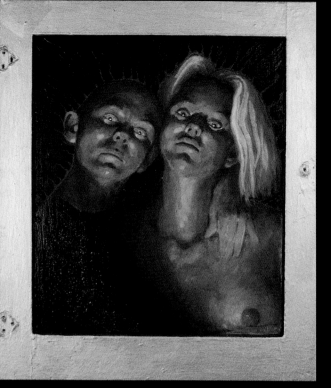

"Two Friends"
1993, Acrylic on Wood, 23" X 20"

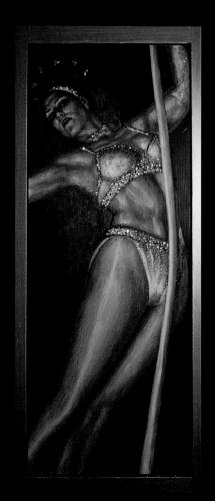

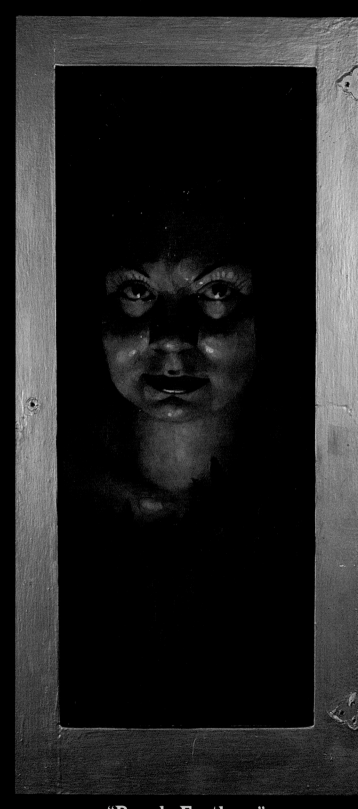

"Purple Feathers"
1993, Acrylic on Wood, 34" X 15 1/2"

"Ariadne"
1999, Acrylic on Wood, 48" X 19"

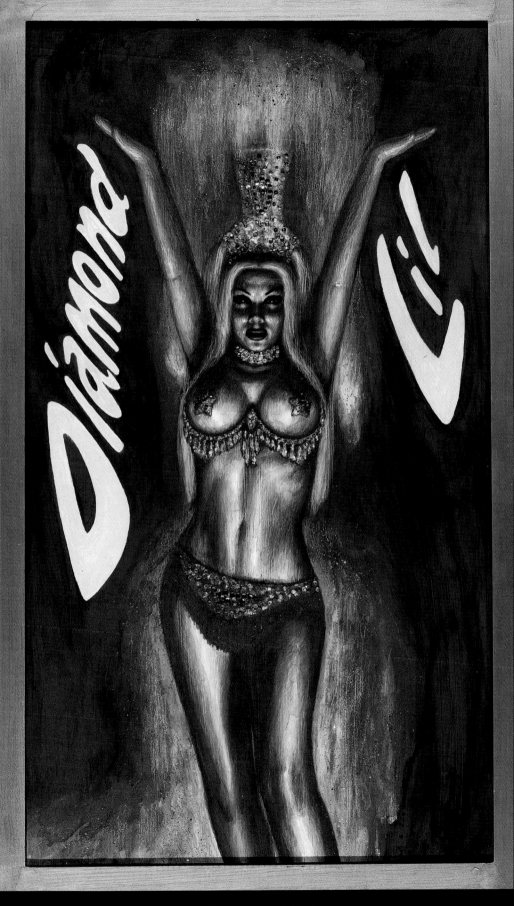

"Diamond Lil"
1999, Acrylic on Wood, 41" X 25"

★WATER★

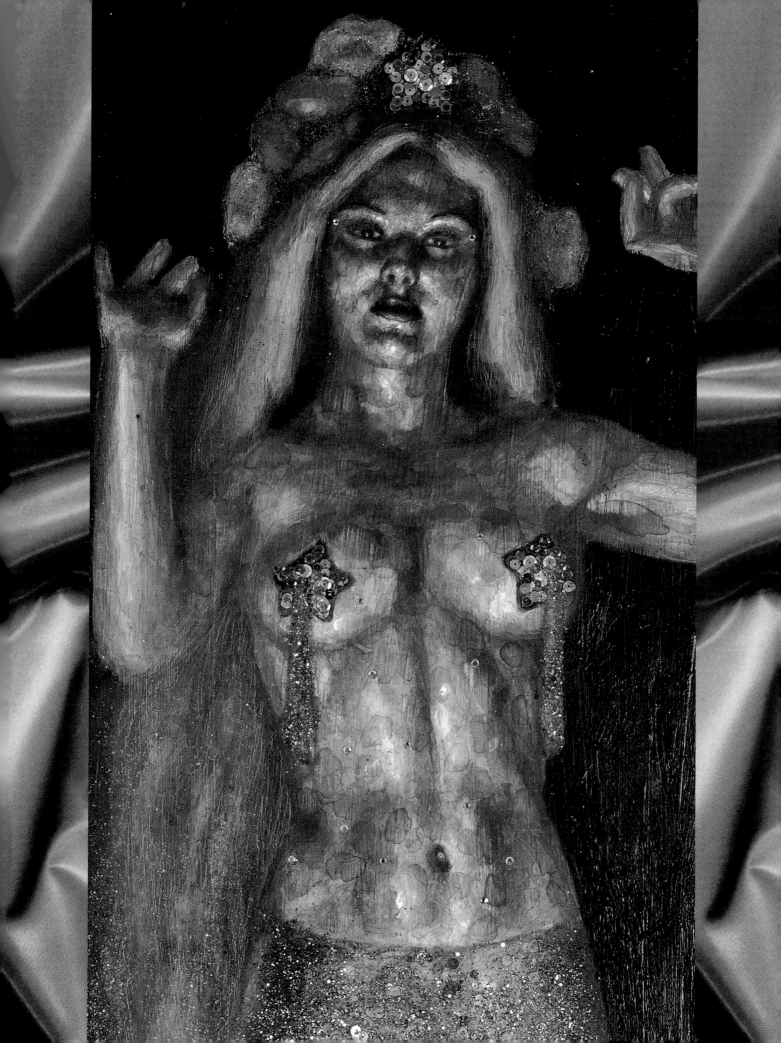

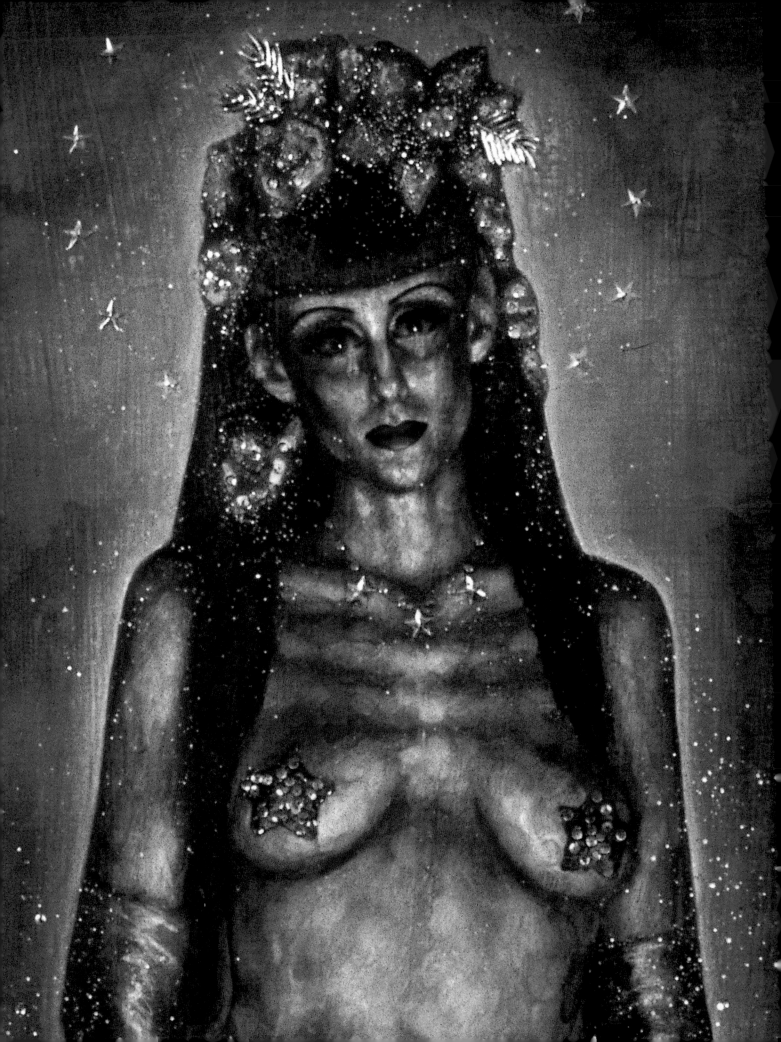

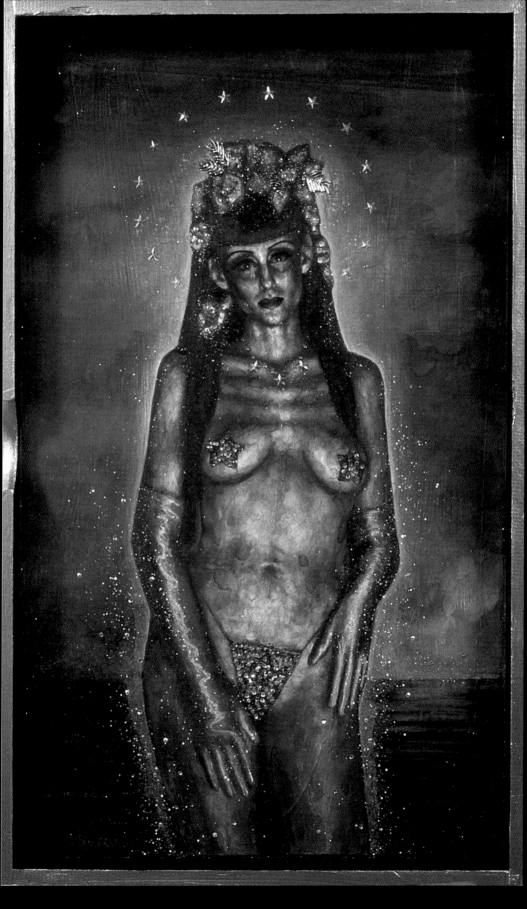

"La Mer"
1998, Acrylic on Wood, 41" X 25"

> ## "*I* am trying to capture my models' larger-than-life selves"
>
> *Stacy Lande*

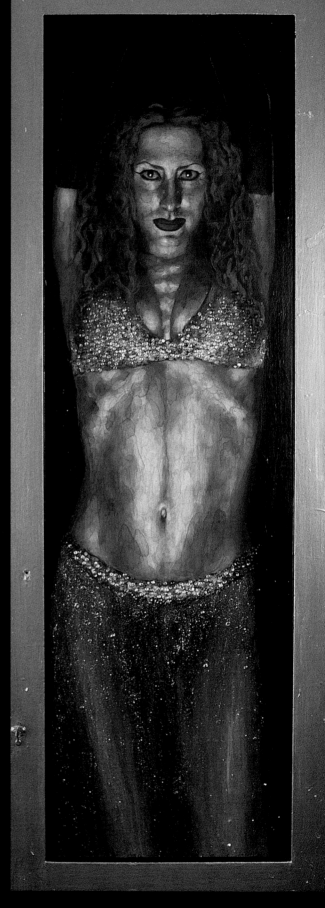

"Shulamit"
1995, Acrylic on Wood, 58" X 20"

"*L*ande's work embodies to me what is truly powerful in art...images that are intensely personal, organic and self-contained, yet able to impart endless worlds of fantasy..."

Frank Kozik

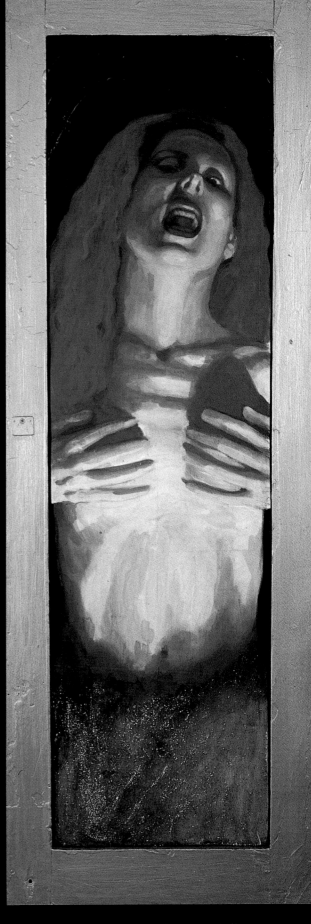

"Aquatic Portrait"
1992, Acrylic on Wood, 43" X 15"

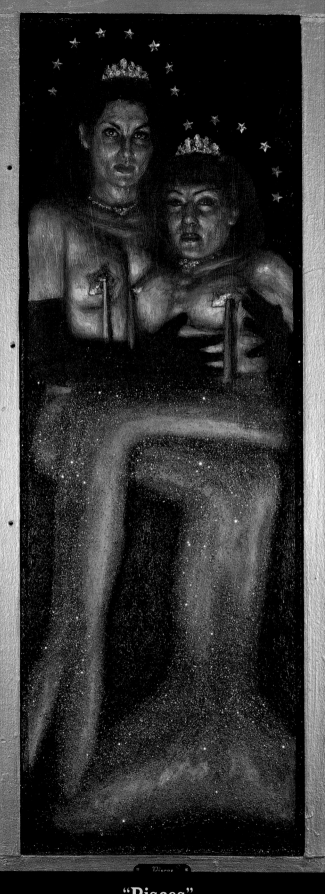

"Pisces"
1999, Acrylic on Wood, 45" X 18"

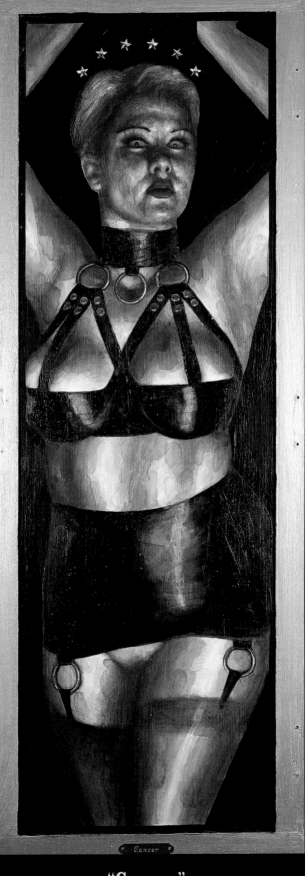

"Cancer"

1999, Acrylic on Wood, 46" X 20"

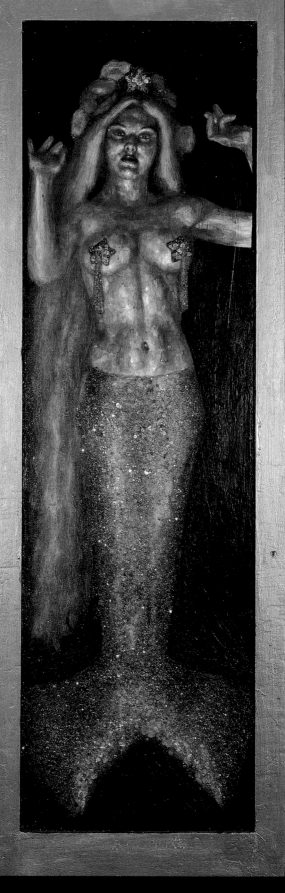

"Sailor's Lament"
1998, Acrylic on Wood, 58" X 20"

"Mermaid Barbie II"
1997, Acrylic on Wood, 30" X 13"

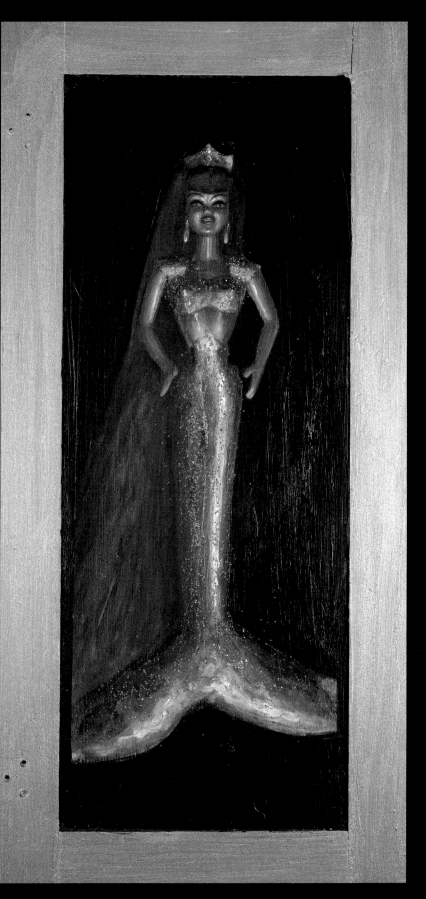

"Dream Date"
1999, Acrylic on Wood, 28" X 13"

"Mermaid Barbie I"
1997, Acrylic on Wood, 28" X 13"

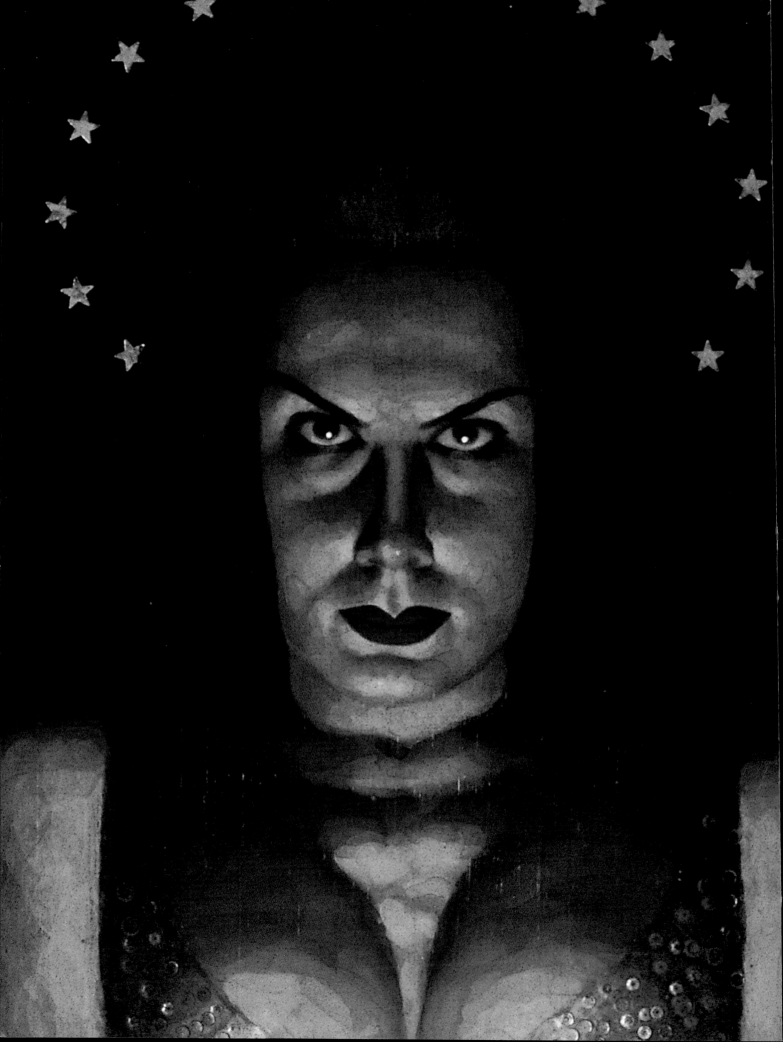

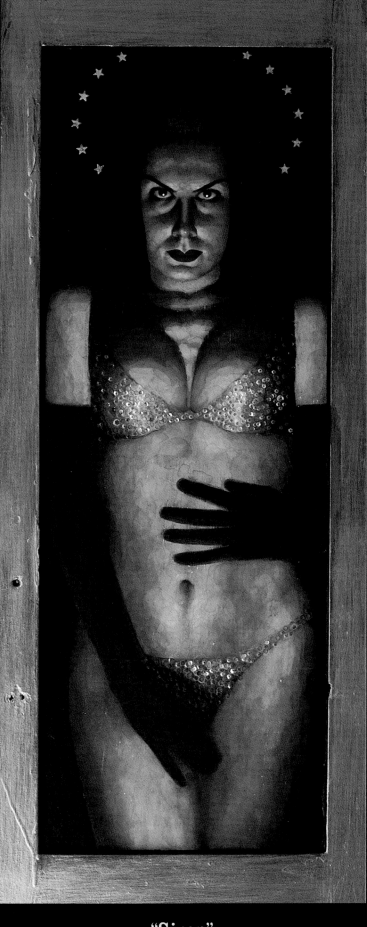

"Siren"
1994, Acrylic on Wood, 44" X 18"

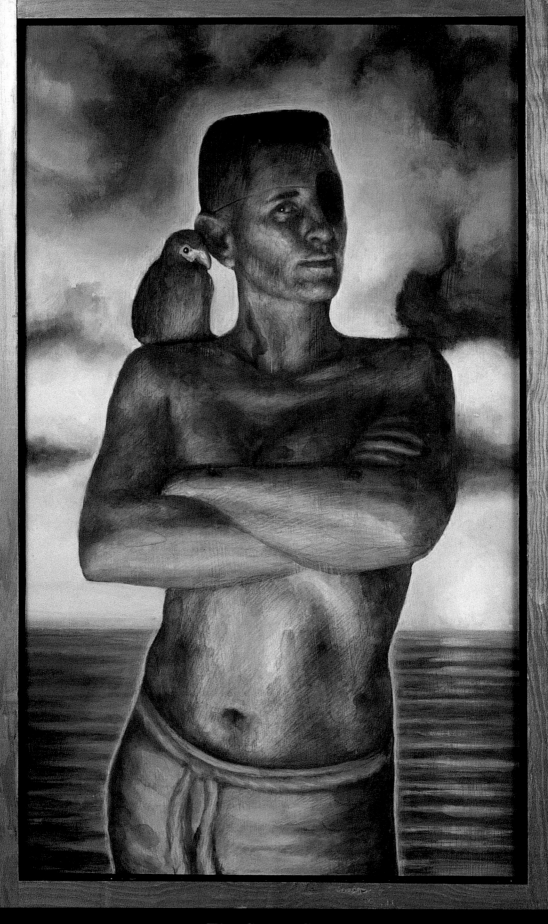

"The Cabin Girl"
1998, Acrylic on Wood, 55" X 40"

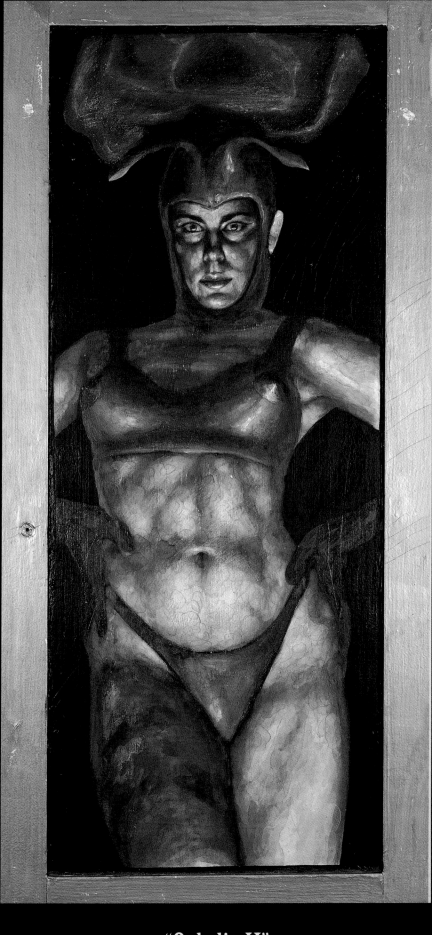

"Ophelia II"
1995, Acrylic on Wood, 48" X 12"

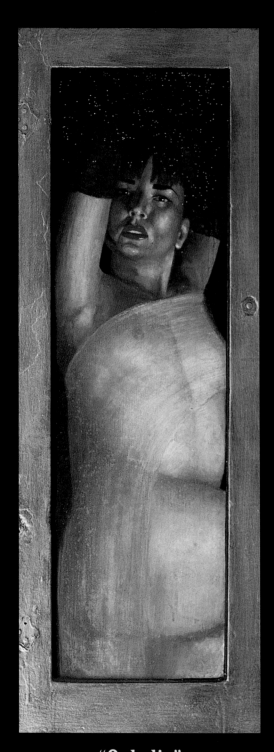

"Ophelia"
1994, Acrylic on Wood, 40" X 15"

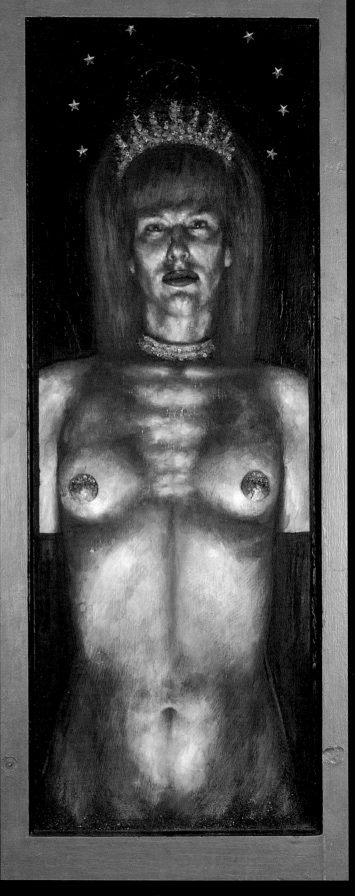

"Leda"
1996, Acrylic on Wood, 48" X 19"

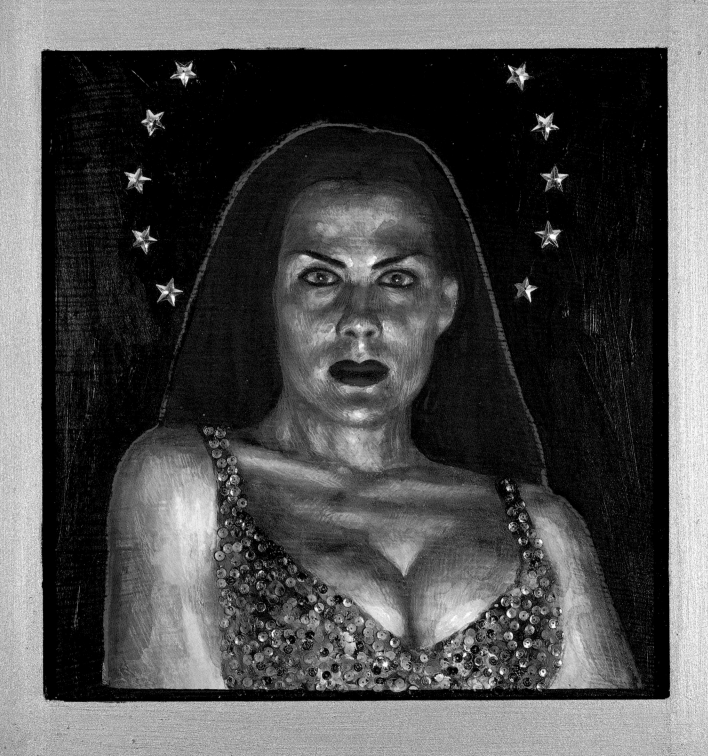

"Siren II"
1999, Acrylic on Wood, 13" X 13"

Selected Exhibitions

Solo Shows

La Luz de Jesus Gallery, Los Angeles, California
Positive Space Gallery, New Orleans, Louisiana
L.A. Gay and Lesbian Center, Los Angeles, California
The Lucky Nun Gallery, Los Angeles, California
EZTV Gallery, Los Angeles, California

Group Shows

La Luz de Jesus Gallery, Los Angeles, California
111 Minna Street Gallery, San Francisco, California
Huntington Beach Art Museum, Huntington Beach , California
Merry Karnowsky Gallery, Los Angeles, California
Roq La Rue Gallery, Seattle, Washington
Track 16 Gallery, Santa Monica, California
Julie Rico Gallery, Santa Monica, California
Zero One Gallery, Los Angeles, California
Vox Populi, Seattle, Washington
LACE Gallery, Los Angeles, California
L.A. City Hall Bridge Gallery, Los Angeles, California

Selected Magazine Articles

JUXTAPOZ, JUXTAPOZ EROTICA,
DETOUR, AXCESS, Japanese "W" and
Petersen's HOT ROD DELUXE

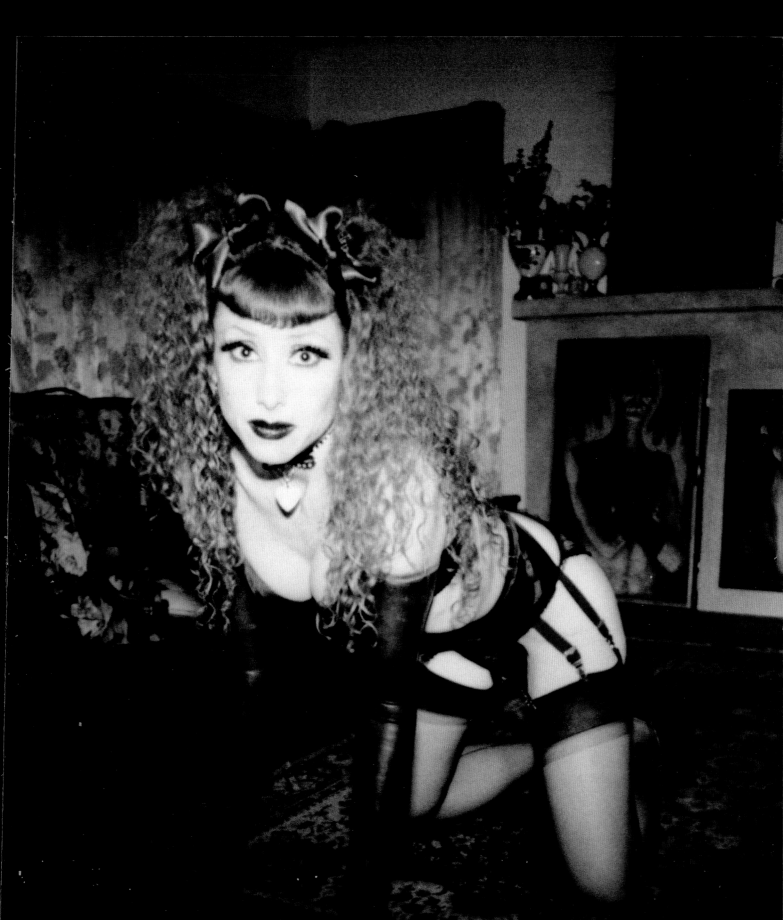

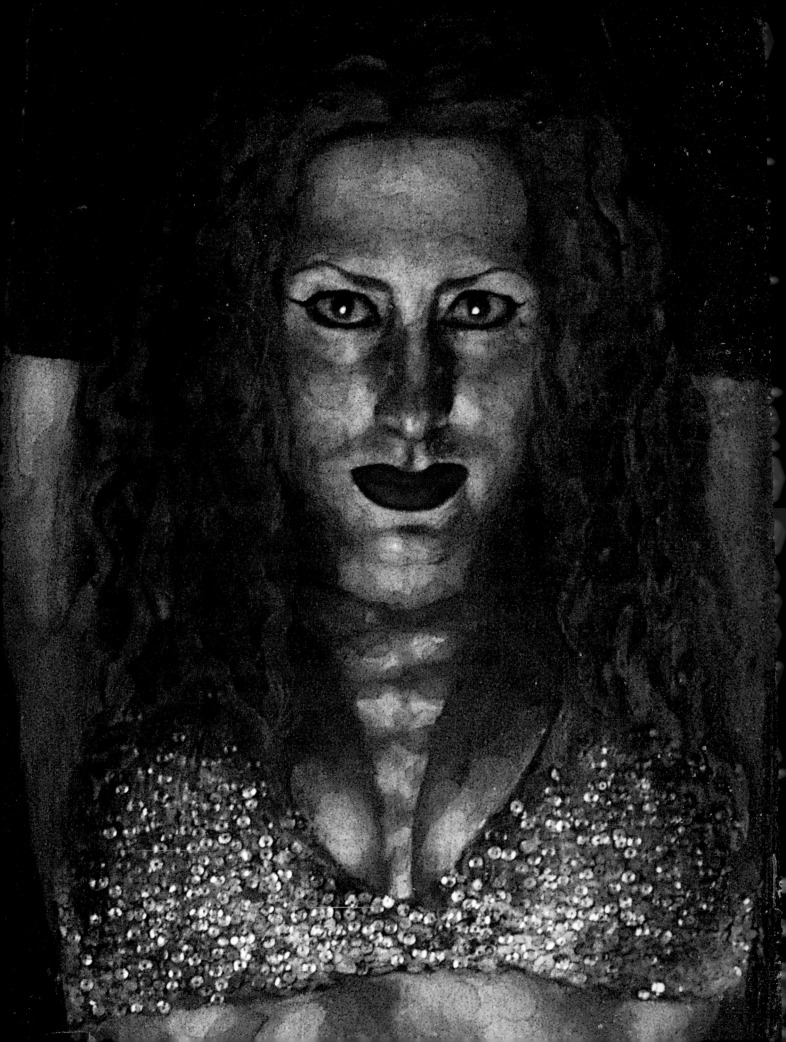